AUBREY

BEARDSLEY.

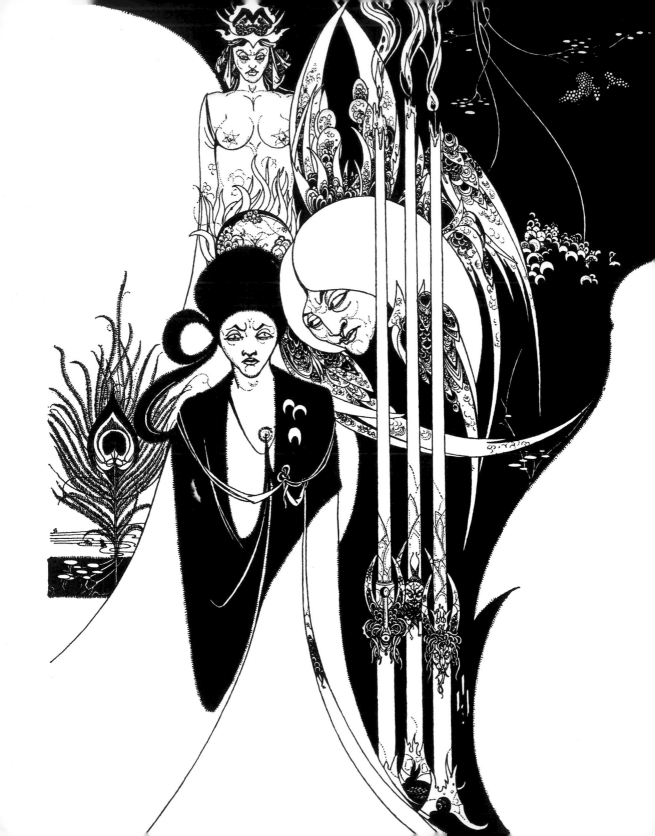

Aubrey Beardsley

Gilles Néret

TASCHEN

KÖLN LISBOA LONDON NEW YORK PARIS TOKYO

Front cover:
The Black Cape, 1893

Page 1:
Self Portrait. Ink drawing, 1892

Page 2:
Of a Neophyte and how the "Black Art"
was Revealed unto Him by the Fiend
Asomuel, 1893. Beardsley gently
mocks his own art

Page 5:
Title-page of *Salome*, 1894

Back cover:
Illustration for *Lysistrata*, 1896

Top: Dancing to Pan's Pipe, c.1896

© 1998 Benedikt Taschen Verlag GmbH
Hohenzollernring 53, D–50672 Köln
Text and concept: Gilles Néret, Paris
English translation: Sue Rose, London

Printed in Portugal
ISBN 3-8228-7200-8
GB

Contents

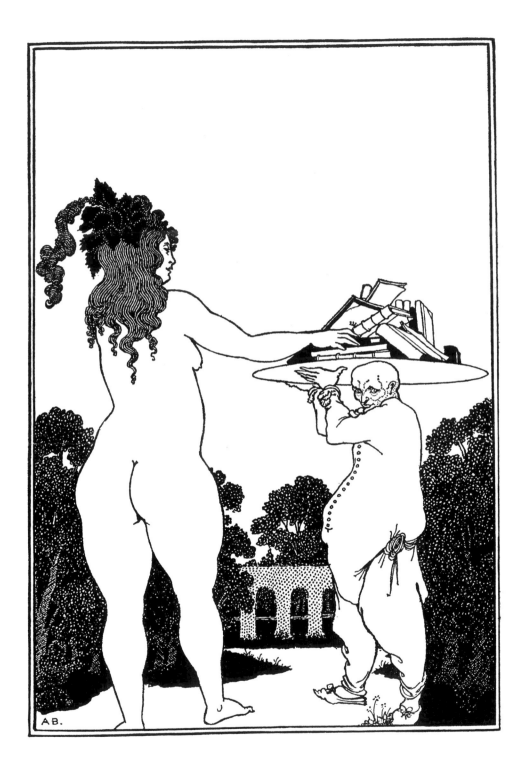

A Dandy in the Victorian Era

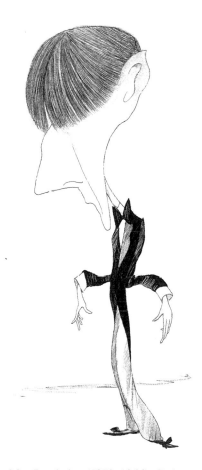

Aubrey Vincent Beardsley died of tuberculosis in 1898 at the age of twenty-five, before the dawning of the Belle Epoque. But the huge impact of the elegant, cynical, sensual and decadent rebellion by this English illustrator and dandy is central to understanding these hysterical and morbid fin de siècle years.

IIis extremely short career, in fact, made him one of the most characteristic exponents of Art Nouveau. His works mark key stages in the development of this new style, as well as fundamental points of reference.

Perverted, satanic, tyrannical, melancholy, mannered, artificial and decadent are just some of the adjectives that have been used to describe this charming, enigmatic and fevered figure, who seemed able to create a unique lexicon of carnal knowledge in pen and ink.

In the name of decency, hypocritical Victorian society imposed silence on certain subjects like sexuality. Beardsley, however, justifiably felt that sexuality had always been one of the mainstays of human existence as well as one of art's main sources of inspiration. The fact that he had taken such an interest in the issue of sexuality in the Victorian Era, and in such a personal way – as Pennell, his first biographer, wrote, he had not "been carried back into the fifteenth century or succumbed to the limitations of Japan" – makes it easier to understand his key importance.

Beardsley's unmistakable style was characterised by his obsession with eroticism. Black was the prevailing colour of his highly-contrasted drawings, comprised of voluptuous, sophisticated arabesques and stylised, elaborately decorated figures. His favourite subject was women, well-endowed women with impressive curves and tiny hands and feet, whom he portrayed erotically, sarcastically and somewhat morbidly in an ultra-refined setting.

Three movements – Decadence, Symbolism and Art Nouveau – dominated the world of art during those years, influencing artists

Max Beerbohm (1872–1956): Caricature of Aubrey Beardsley, c.1894

Left:
Bookplate for Herbert Pollitt, c.1896. Beardsley was particularly proud of this nude figure which he thought much better than the nudes in *Le Morte Darthur*

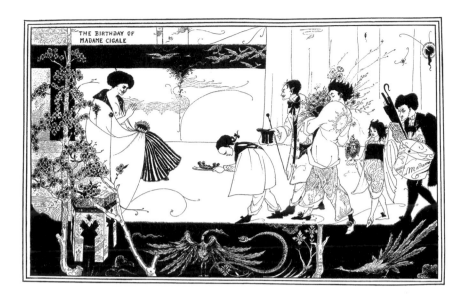

The Birthday of Madame Cigale, 1892. Madame Cigale, a courtesan, is receiving presents from a bizarre procession of admirers and clients. Beardsley described them as "Fantastic impressions treated in the finest possible outline…" A characteristic feature of Beardsley's work from the start was his ability to convey the most whimsical fantasies in forms of the utmost beauty and purity. This drawing also shows the marked influence of Japanese art on the artist.

Right: preparatory drawing for the cover of *Salome*, 1894

to different degrees depending on their temperament. It is interesting to examine the position held by any of the artists working at that time with regard to these movements and, as pointed out by the French curator José Pierre, this phenomenon was, in fact, an international one: "Gustave Moreau, fairly Decadent but fundamentally Symbolist, was only interested in Art Nouveau out of a love for the arabesque; Félicien Rops, a much more Decadent artist, was only slightly Symbolist and not at all influenced by Art Nouveau, Gauguin was not at all Decadent but clearly Symbolist and one of the immediate precursors of Art Nouveau; as for Beardsley, he was profoundly influenced by Decadence and Art Nouveau, but hardly at all by Symbolism."

The French newspaper *Le Figaro* published an imprecatory and somewhat racist definition, highlighting the international aspect of these three movements: "This savours of the obscene Englishman, the morphine-addicted Jew or the wily Belgian, or a hotchpotch of all three of these vile creatures." In fact, what these three "vile creatures" had in common, the principal interest they all shared, was women: all three artists were interested in exploring the erotic. They were also accused of spreading the foulest perversions, anything that glorified the pleasures of the flesh in the greatest contempt for the time-honoured institution of marriage and the holy imperatives of procreation. Beardsley earned the supposedly insulting label of Decadent, although he could never have

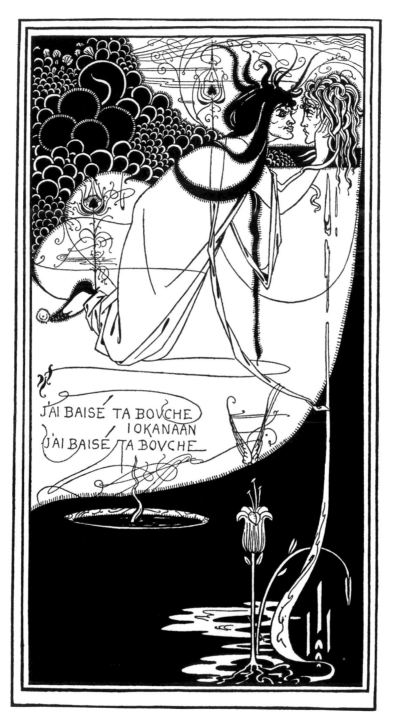

10 Salome with the head of John the Baptist, 1893
This illustration earned Beardsley the commission to illustrate Oscar Wilde's book.

been described as innocent, given his provocative behaviour. Decadence can admittedly be regarded as an extreme form of romanticism, itself expressing an artistic reaction to the social changes brought about by the industrial revolution. The natural enemy of Decadence was decency, a well-established system of social conventions upheld by a new ruling class comprising the industrial and commercial middle classes who sought to deny the existence of unpleasant realities. This attitude was highlighted by Osbert Burdett in *The Beardsley Period*: "Victorian convention imposed, in the name of decency, a conspiracy of silence concerning them… The facts about industrial life, social life, private life, were suppressed and the fate of anyone who mentioned their shortcomings was to be denounced as a corrupter of morals … the only remedy was ruthlessly to strip the masks from the realities".

Homosexuality was, by its very nature, also a provocative issue that shared close affinities with Decadence. Oscar Wilde, during his trial of 1895, was dubbed "The High Priest of Decadence" by the British press. Beardsley, however, was bisexual rather than homosexual. José Pierre, referring to his sexuality, cites: "an entire British tradition, started by Walpole, Lewis and Beckford with the Gothic romance and continued by Byron and Wilde, who both had a wife and children".

The unfinished tale of *Venus and Tannhäuser* (p. 59) provides a tempting glimpse of this bisexual paradise. Beardsley who, throughout his life, hesitated between being an artist or a writer, produced, according to the French surrealist writer, André Pieyre de Mandiargues, "a book which is probably unique for the somewhat childlike paganism that is more often harboured in the English soul than commonly believed". This book, with its extravagant Rococo setting, costumes and poses, is a naïve description of an encounter, hardly Wagnerian in spirit, that takes place in a world governed by a delightful, light-hearted permissiveness.

Rather than courting accusations of sodomy, at the same time as Wilde, a dandy like Beardsley preferred to countenance rumours about his incestuous relationship with his sister, as much a scandal of course, but a more glorious one, firmly rooted in a British tradition started by Lord Byron. Beardsley was, in fact, interested in all types of sexuality. Although he was fascinated by so-called *curiosa* from all periods and extremely knowledgeable about the erotic art of Ancient Greece, Japanese prints and eighteenth-century French engravings, very little is known about his

Illustration for *Das Rheingold* (detail), or making a comedy of Wagner's opera

Frontispiece for *The Wonderful History of Virgilius, the Sorcerer of Rome*, 1894. This drawing displays the direct influence of Japanese prints.

Katsukawa Shunsen: *A Courtesan*, c.1820

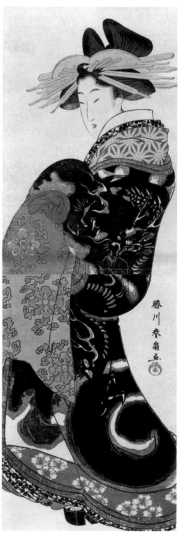

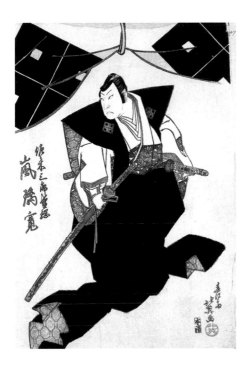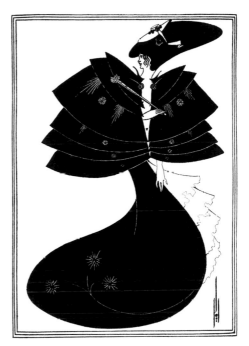

sexual preferences and fantasies. There were, of course, his trips to France with his friends Raffalovich and Smithers – who, unlike him, were both in good health – but these proved to be little more than excuses for committing excesses of debauchery that brought on renewed haemorrhaging and serious relapses of his tuberculosis.

As his mother has stressed, Beardsley was an extremely sickly child from his earliest childhood, "like a delicate piece of Dresden china". His short life was punctuated by a succession of attacks. At the age of eighteen, employed in an insurance office, he wrote to his former teacher, who had detected his talent early and had enthusiastically encouraged him, saying: "I have been so dreadfully ill. Some weeks ago I had a bad attack of blood spitting… My Christmas has been kept on slops and over basins…" This happened frequently as the tuberculosis followed its inexorable course, forcing him to spend long periods resting. In 1891, he even seriously considered giving up drawing to embark on a less tiring literary career.

In view of this state of affairs, it is a wonder that this delicate and fevered dandy, whose output only spanned some four years

Left: Shunkosai Hokuyei: Portrait of an Actor, c.1830

Right: The Black Cape, 1893. This illustration of a fashionable woman of 1893, profoundly influenced by Japanese art, was substituted for an image that had been withdrawn from *Salome*.

Beardsley's foray into the field of poster design resulted in a range of sensual and feminine representa-

tions of women who had little connection with the subject matter. Here, two examples dating from 1894.

(between 1893 and 1896), made such an impact on his period. Although all of Beardsley's work was as an illustrator and precisely because it was, his "…appearance […] in 1893 was the most extraordinary event in English art since the appearance of William Blake, a little more than a hundred years earlier." (Holbrook Jackson, *The Eighteen Nineties*, 1913). In four years, in fact, despite his ill health, Beardsley had managed to publish four masterpieces, four infinitely varied, fascinating gems, that formed the cornerstones of his art and renown. First, *Le Morte Darthur*, in 1893 (pp. 20–29), after the work by Sir Thomas Malory, for which he exploited the new photo-mechanical methods of reproduction with consummate skill. Then *Salome*, in 1894 (pp. 30–43), which earned him a dedication from the author, Oscar Wilde: "For Aubrey: for the only artist who, besides myself, knows what the dance of the seven veils is, and can see that invisible dance. Oscar." Then *The Rape of the Lock*, in 1895–1896 (pp. 64–69), after a poem by Alexander Pope, the drawings for which he executed mainly in Paris, writing to his friend Smithers from there, after the trial of Oscar Wilde that lost him his position as art editor of *The Yellow Book*: "Paris suits me very well… I don't know when I shall return to London, filthy hole where I get nothing but snubs and the cold shoulder". Last but not least, *Lysistrata* by Aristophanes, also in 1896 (p. 70–79), the *pièce de resistance*, which saw Beardsley abandon the intricate eighteenth-century French style of *The Rape of the Lock* to return to the elegance and linear purity of *Salome*. From then onwards, his work was interrupted by his worsening health and he could do little more than make sketches for various projects that never came to fruition. This did not prevent him, on the advice of his doctors, from taking the dubious cure of travelling, dying at Menton, his last port of call, during the night of 15/16 March 1898.

Two decisive factors contributed to Beardsley's great success. Firstly, the scandal produced by his works when they were published and their undoubted impact. A product of the combined influences of Kate Greenaway, Burne-Jones, Whistler and Japanese art, Beardsley's bold, distinctive style was bound to cause a sensation. This hostile reaction initially stemmed from the startling formal innovations of this new style, exploiting the stark contrast between black and white to devastating effect. It was then fuelled by the fact that, continuing a very recent tradition started by Swinburne, the young artist opted for a provocative brand of eroticism,

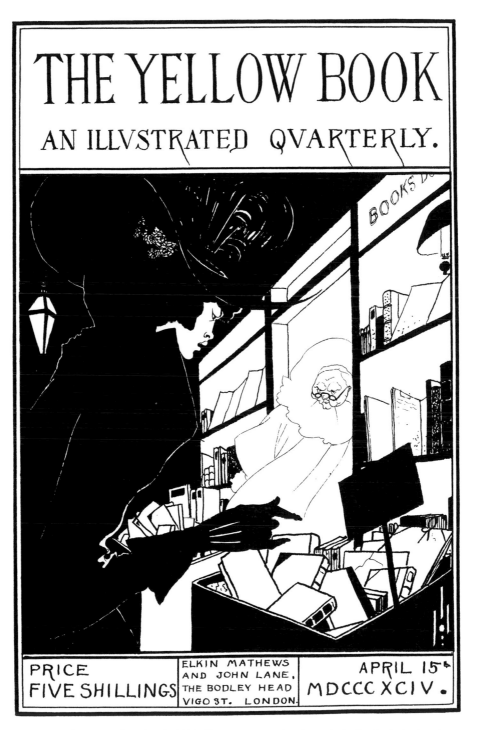

Prospectus for *The Yellow Book*, 1894. The woman sorting through the books is depicted as a demimondaine, a sensual, immoral woman of the night, typical of Beardsley's heroines.

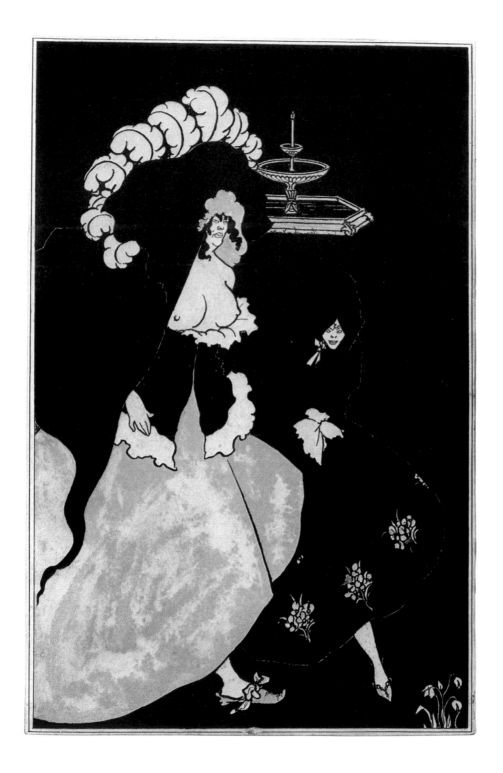

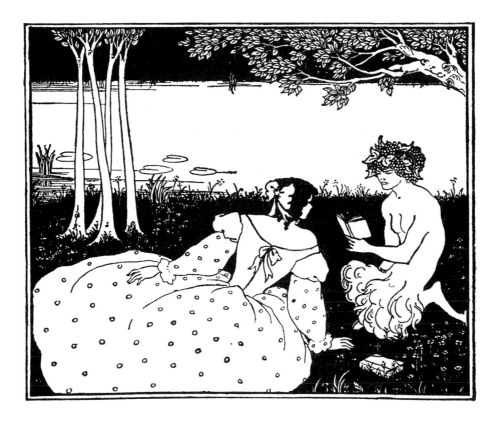

a particularly risky decision to take in Victorian England, as Oscar Wilde soon found out to his cost. Beardsley, who had been publicly condemned for his collaboration with Wilde on *Salome*, was not spared either. He incurred the wrath of the respectable *Times* which described his illustrations as "fantastic, grotesque… unintelligible for the most part, and, so far as they are intelligible, repulsive". The *Westminster Gazette* went even further, declaring, with regard to the drawings printed in *The Yellow Book*: "…we do not know that anything would meet the case except a short Act of Parliament to make this kind of thing illegal…"

The second reason was that graphic art had just begun to come into its own and technicians were in the process of developing photo-mechanical reproduction processes, particularly the line-block which made it possible to print millions of copies of a piece of work, all of the same high quality. Beardsley swiftly adapted his drawing technique to suit this new system, the end result being so close to the original that he himself made mistakes trying to dis-

Cover of *The Yellow Book*, No. 5 1895. A gentler, less sinister version of *The Mysterious Rose Garden* (p. 48), this pastoral scene depicts a gallant faun in concourse with an innocent young girl.

Left: *Messalina*, 1895. This drawing tallies perfectly with Juvenal's description in his *Sixth Satire*, although Beardsley made it into a night piece that was more reminiscent of the streets of London than of Ancient Rome.

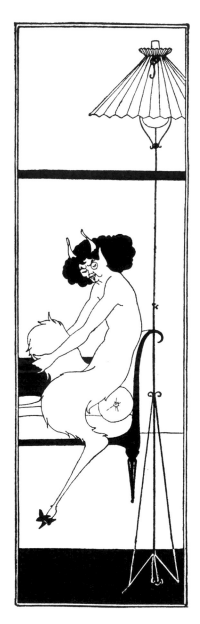

tinguish between original and copy. This process, which was also fairly inexpensive, made it possible to mass produce works at universally affordable prices.

The true precursor of Andy Warhol, Beardsley, who only produced drawings – no paintings exist by the artist, except for some wash drawings and water-colours – was actually the first artist to create a work of art that was no longer a one-off but what is now known as a multiple. Naturally, Beardsley's original illustrations have become collectors' items. But, as José Pierre notes, ultimately, a Beardsley original, reproduced thousands of times, can no longer be worth any more than its copy.

A genuine Decadent, Beardsley was fond of inserting anachronistic elements into his drawings, which form a considerable part of their charm. He enjoyed portraying Salomé either as a fashionable woman of 1893 or as a North African belly dancer, Tannhäuser as an eighteenth-century nobleman in rococo style, hardly Wagnerian in spirit, and the heroines of Aristophanes' *Lysistrata* wearing simple neo-classical negligées, while Pope's *The Rape of the Lock* was swamped by an extravagance of decorative elements and a profusion of lines in rococo Liberty print style.

But it should not be forgotten that these attractively Decadent exteriors concealed his fear of the death that shadowed him and was soon to claim him. Beardsley drew the inspiration for his masterpieces from texts that glorified love and death in equal measure, from *Le Morte Darthur* by Thomas Malory and *Salome* by Oscar Wilde to *The Black Cat* by Edgar Allan Poe (p. 87) and Messalina from Juvenal's *Satires* (pp. 80–83). Like many sinners, Beardsley converted to Catholicism shortly before his death, denying *in extremis* what were, for him, no more than "naughty" drawings, and which nonetheless won him widespread acclaim: licentious, lighthearted drawings, full of well-endowed women with bare breasts and buttocks liberally displayed, much to the delight of huge erect phalluses, standing eagerly to attention.

Drawing for the cover of *The Dancing Faun*, by Florence Farr, published by John Lane, 1894

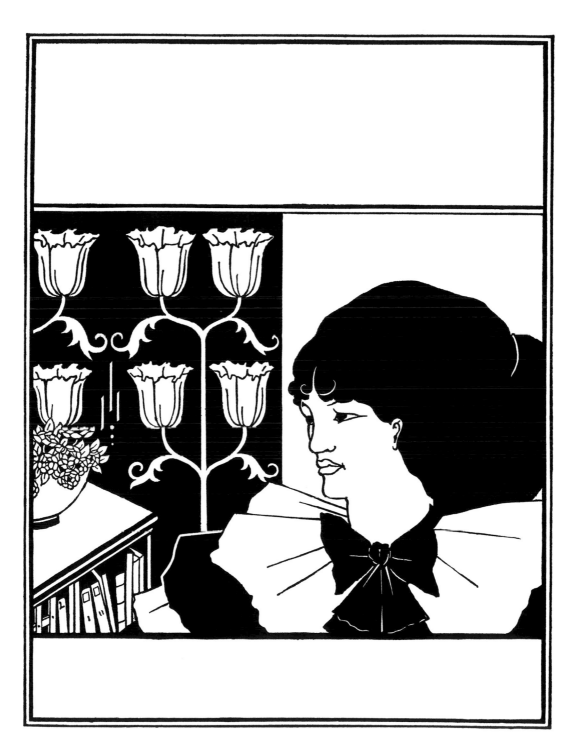

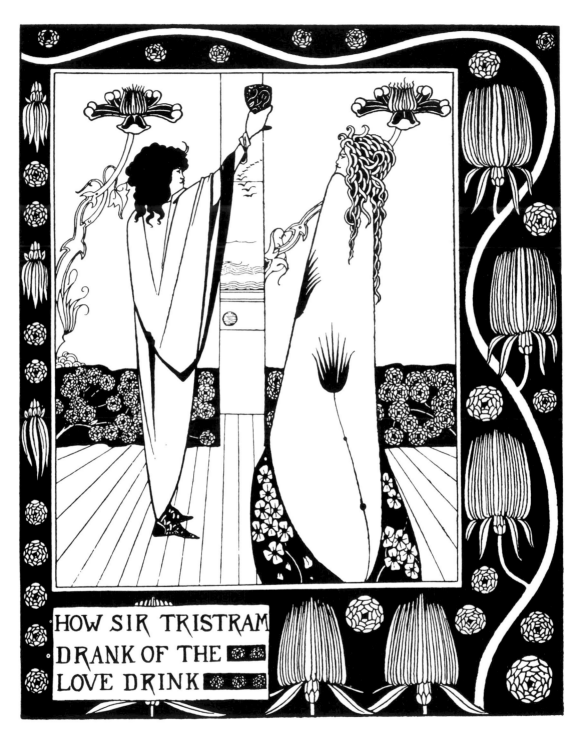

HOW SIR TRISTRAM DRANK OF THE LOVE DRINK

Illustration for *Le Morte Darthur*, 1893

THE BIRTH LIFE AND ACTS OF KING ARTHUR OF HIS
NOBLE KNIGHTS OF THE ROUND TABLE THEIR
MARVELLOUS ENQUESTS AND ADVENTURES
THE ACHIEVING OF THE SAN GREAL
AND IN THE END LE MORTE DAR≥
THUR WITH THE DOLOUROUS
DEATH AND DEPARTING
OUT OF THIS WORLD
OF THEM ALL.

Le Morte Darthur

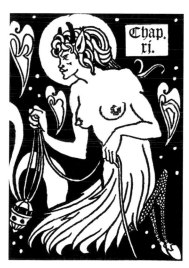

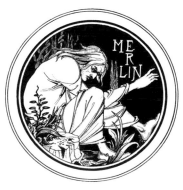

The London publisher, J. M. Dent, was keen to find someone to illustrate the medieval English version of the legend of King Arthur, *Le Morte Darthur*, written by Sir Thomas Malory and first published by Caxton in 1485. Dent intended to rival the books then being published by William Morris at the Kelmscott Press. The illustrations were by Burne-Jones and the decorative designs by Morris and everything was printed using hand-cut wood blocks. Dent was hoping to achieve the same result at a more competitive price by using an un-

known artist and the new photographic techniques of reproduction. Impressed by early works by Beardsley, like *The Birthday of Madame Cigale* (p. 8), which showed the influence of Burne-Jones and with which the artist had already started to make his name, he commissioned the young artist to illustrate *Le Morte Darthur,* which was to be published in two volumes and sold by subscription. Beardsley's fee was £250, which he re-

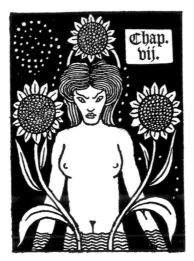

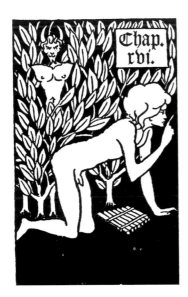

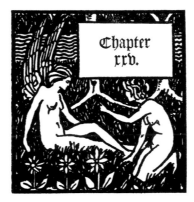

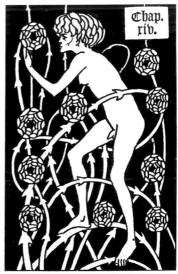

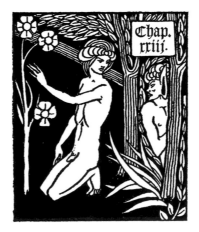

garded as: "Not bad for a beginning". However, Dent had not realised that Beardsley was already moving away from what he regarded as Burne-Jones' well-worn manner and was developing a new style that, in actual fact, was to secure the success of the publication. He later described this style as: "…an entirely new method of drawing and composition, something suggestive of Japan but not really Japonesque." As Simon

Wilson comments in his book *Beardsley:* "A comparison of a page […] from *Le Morte Darthur* with a page from one of the Kelmscott books that Beardsley was supposed to be imitating reveals at once the distance he had travelled from the restrained and narrow medievalism of Morris. The light, delicate foliage of Morris's borders has been replaced by powerful organic plant forms pulsing with life; the figures of Burne-Jones, mere deco-

rative ciphers, have been replaced by startlingly vivid personages evidently in the grip of strange emotions". Beardsley was fascinated by the legend of Tristan and Isolde, particularly its full-blown romantic treatment by Wagner in his opera. This tragedy about a fatal passion was bound to appeal to him. There can, in fact, be no emotion more intense than that felt by two people who, expecting death, discover simultaneously they are passionately

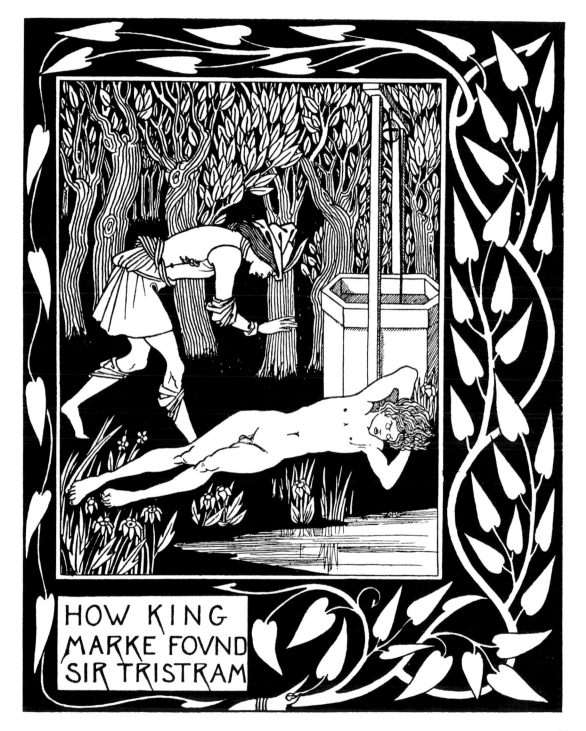

HOW KING
MARKE FOVND
SIR TRISTRAM

How a devil in Woman's likeness would have tempted Sir Bors

How Queen Guenever rode on Maying.

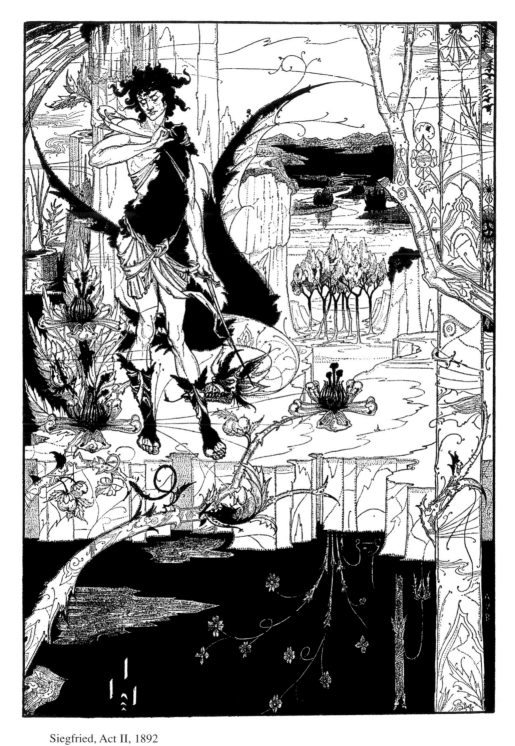

28 Siegfried, Act II, 1892

in love. Despite his love for Isolde, Tristan is duty-bound to escort her to his king whom she is to marry. Isolde, thwarted, prepares a poisoned drink that she offers him before drinking of it herself. He declares: "The cup that I now take will cure the hurt completely". Fortunately Isolde's faithful servant has substituted a love philtre for the deadly drink... Beardsley, with his restrained lines and effective use of blacks and whites, whose impact is enhanced by the decorative border designs, skilfully manages to conjure up the strength of the natural forces seething beneath the lovers' outward calm (*How Sir Tristram Drank of the Love Drink*, p. 20). The inextricable nature of love and death was one of the major themes of the romanticism that held a particular appeal for Beardsley. Around the same period, and still under Wagner's spell, Beardsley drew his *Siegfried* (p. 28) which he regarded as "the culmination of his 'fine line' style" (Simon Wilson) of his early period. Burne-Jones, he wrote in self-congratulatory manner, "has given my *Siegfried* a place of honour in his drawing room..." Burne-Jones, his elder, who always encouraged Beardsley, had quickly spotted the young artist's genius, because this was one of his finest drawings. It shows Beardsley's ability to meld the influences of Japanese art, Renaissance art and Whistler to produce his own distinctive style. *The Kiss of Judas* (p. 29) and *The Neophyte* (p. 2) seem to mark a transitional stage between *J'ai baisé ta bouche* (p.10) and the illustrations for *Salome* (p. 30).

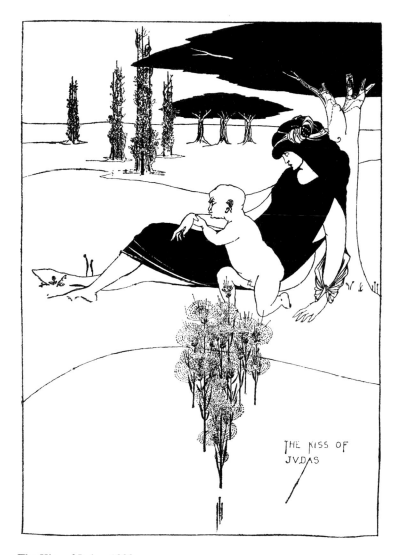

The Kiss of Judas, 1893

They were both drawn for the magazine *Pall Mall*. Beardsley was very fond of his diminutive monsters, like the one in *The Kiss of Judas,* who, according to a Moldavian legend, are descended from the traitor, Judas, and are "prowling about the world, seeking to do harm, and [...] will kill you with a kiss". The *Neophyte*, however, one of Beardsley's visual jokes, shows the artist himself being initiated into the "Black Art" by a fiend!

Salome

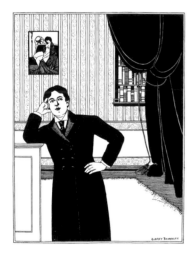

Portrait of Oscar Wilde, undated

Top: Tail-piece to *Salome*, 1893

It was through the kindly Burne-Jones, who had a great deal of admiration for his young colleague, unmarred by envy, that Beardsley, at the age of eighteen, made the acquaintance of Oscar Wilde. The latter was in the process of writing *Salome* in French (translated into English by his lover, Arthur Douglas). The young artist, as enthusiastic as he was ambitious and supremely gifted, effortlessly created a debauched and theatrical decorative style, in part inspired by Greek vase designs. He gave them a slightly malignant elegance, using the same rhythmic and ornamental elements as in the abstract decoration of Arab palaces. His unmistakable style again provides an ironic and distinctive treatment of the decadent themes of the evil, castrating woman. Salome, whom

Philippe Jullian calls "the goddess of Decadence", a desirable young dancer, was a source of inspiration for the entire period, including artists as disparate as Flaubert, Huysmans, Mallarmé, Richard Strauss, Wilde and Beardsley. Salome had, until this date, tended to be confused with Judith, the Jewish heroine who cut off the head of the Assyrian general Holofernes, after sacrificing her virtue to him. But Judith was acting out of patriotism, which is far from the case with Salome, who bears a closer resemblance to the *Femme Fatale*, the Vamp, a heroine greatly feared by *fin de siècle figures* like Oscar Wilde or Aubrey Beardsley. They took Salome's corrupt decadence to even greater lengths, making much of her triumph at obtaining the head of John the Baptist through her

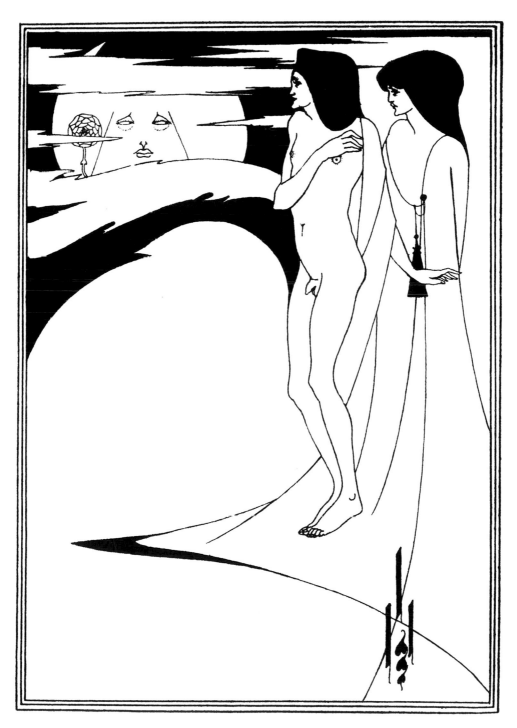

The Woman in the Moon: "Look at the moon! How strange the moon seems! She is like a woman rising from a tomb".

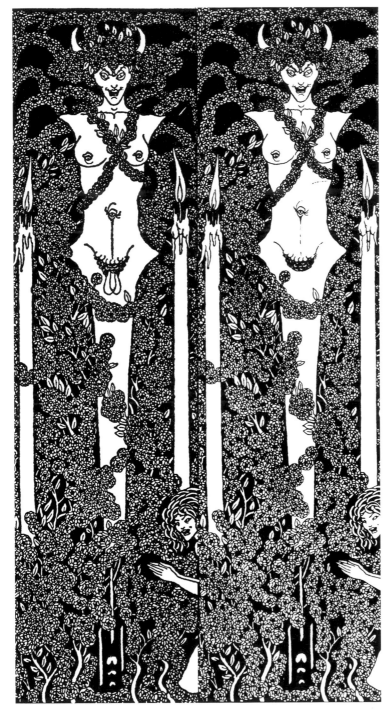

lewd contortions as an oriental belly dancer in *The Stomach Dance* or *The Dance of the Seven Veils* (p. 41), and by causing the lustful dancer to kiss the head of the decapitated saint (p. 43). A sentiment that Flaubert described, just as applicable here although it originally referred to *Salammbô*, as a "type of curiosity and something akin to lust without the erection". In psychoanalytical terms, the decapitated head of the poet symbolises castration. John the Baptist plays the role of the decapitated hero here. Beardsley did not spare Oscar Wilde whom he readily depicts as the moon, *The Woman in the Moon* (p. 31); or lustful Herod, *The Eyes of Herod* (p. 38); or the master of ceremonies, *Enter Herodias* (p. 37). The relationship between Wilde and Beardsley was in fact a difficult one and there seems to have been little love lost between them. Wilde's trial caused the artist to be dismissed from *The Yellow Book* and forced him to take refuge in Paris for a time, while *The National Observer* singled them both out for criticism: "…and the Decadents, of their hideous conceptions of the meaning of Art… there must be an absolute end." Nevertheless, the play and its illustrations again focused on the typically romantic theme of love and death and highlighted their close affinity, not only marking one of the key stages in the emergence of Art Nouveau but also constituting representative works that helped to define the new style. The illustrator was much more adventurous in his use of eroticism than the writer, who merely relied on the force of suggestion. Whereas in the text, Salome complained that

The title-page of *Salome* and *Enter Herodias,* retouched for the prudish, hypocritical censors

Herod was always looking at her with lustful eyes: "Why does the Tetrarch look at me all the while with his mole's eyes?" Beardsley introduced a large number of phallic symbols that conveyed Herod's desire: candlesticks with huge candles held up by well-endowed cherubs, an overly long peacock's neck, erect trees, an opulent hothouse atmosphere (p. 38). Always provocative, Beardsley did not hesitate to introduce a wide range of erotic elements into his drawings that he knew were bound to shock: an abiding characteristic of his art that he regretted just before his death. His irate publisher, John Lane, decided to remove the genitalia marring the title-page (p. 32) and ensured the page's modesty with a vine leaf in *Enter Herodias* (p. 33), but did not notice the phallic candlesticks and the dwarf's huge erect member concealed under his robe, level with the candle flame (p. 37). He also did not notice the musician's arousal at Salome's erotic dance in *The Stomach Dance* (p. 41). Similarly, the first version of *The Toilet of Salome* (p. 39) was rejected because the naked figure sitting on the Japanese stool was shown with pubic hair and had to be replaced by another more modest version (p. 40).

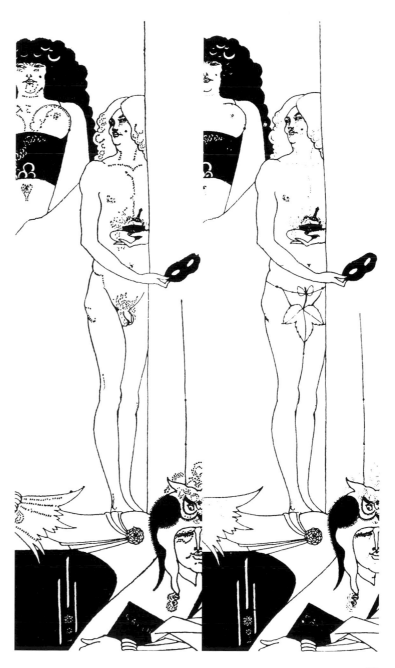

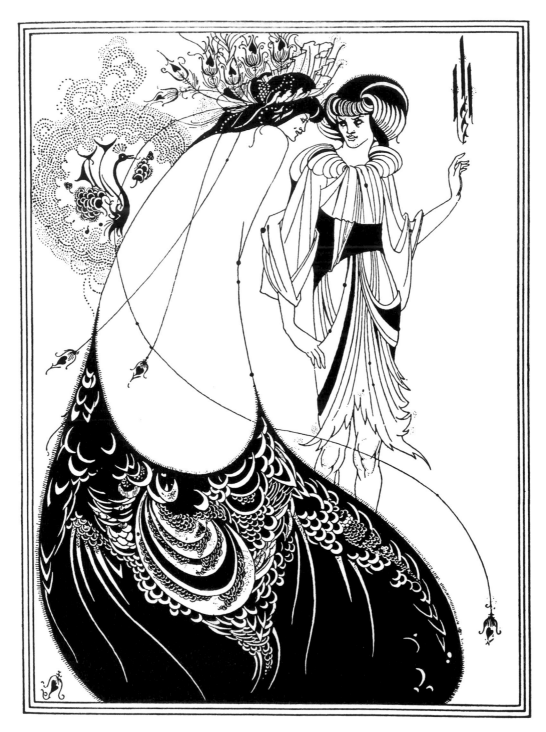

34 The Peacock Skirt: "I am Salome, daughter of Herodias, Princess of Judea"

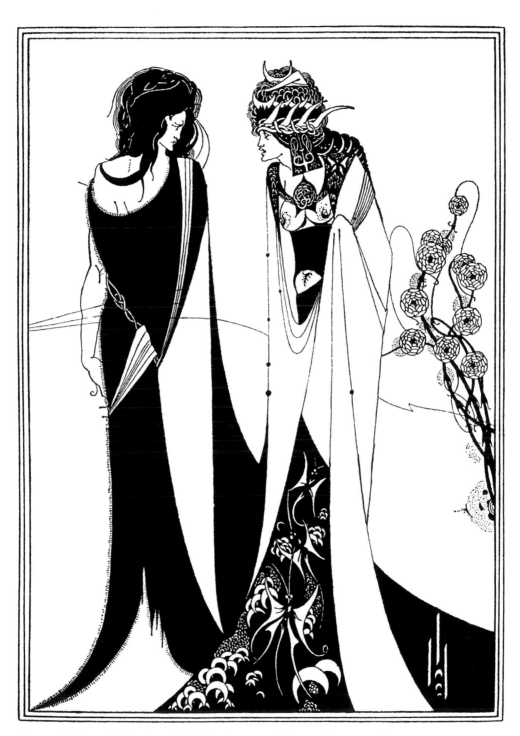

John and Salome: "Wherefore doth she look at me, with her golden eyes…?" 35

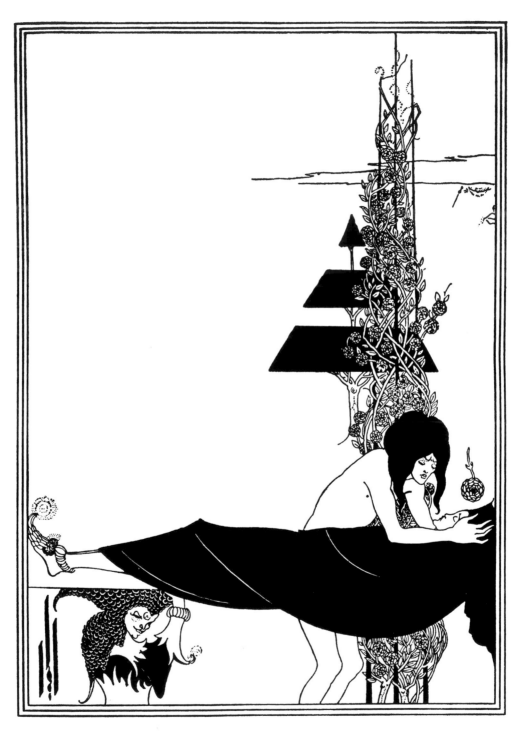

A Platonic Lament: "I will kiss thy mouth, Iokanaan, I will kiss thy mouth."

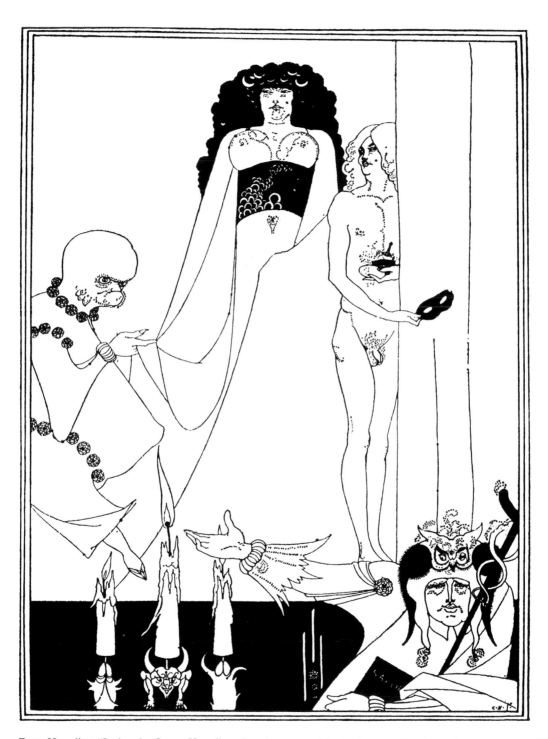

Enter Herodias: "Is that the Queen Herodias, she who wears a black mitre sewed with pearls…" 37

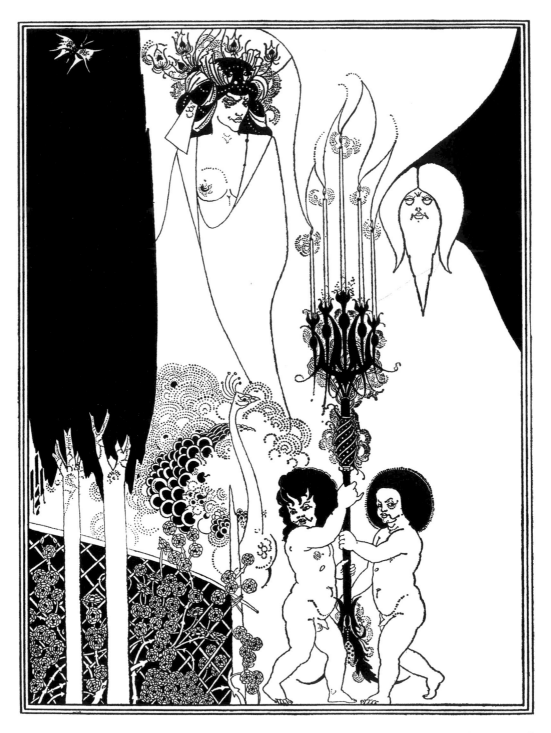

38 The Eyes of Herod: "Salome, come and sit next to me. I will give thee the throne of thy mother."

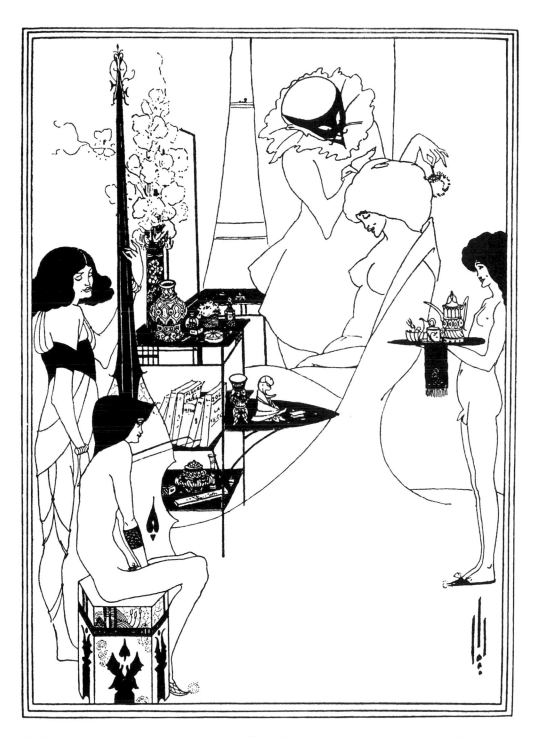

The Toilet of Salome (censored first version): "She is like a narcissus trembling in the wind." 39

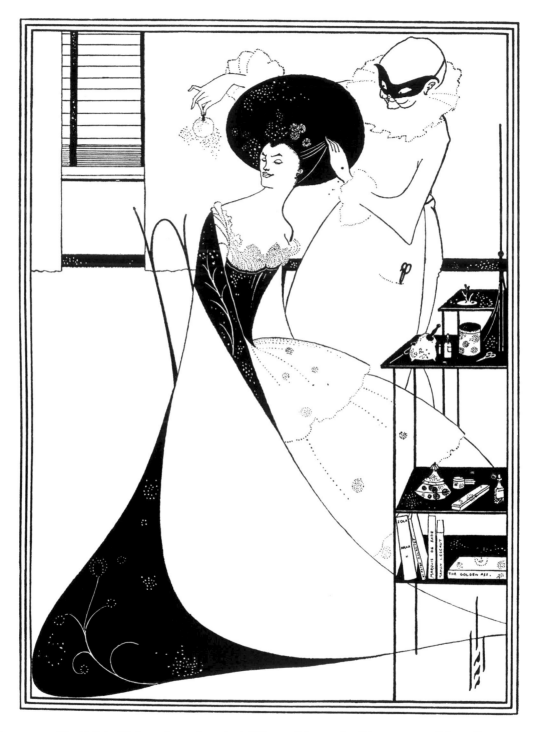

40 The Toilet of Salome (second version): "Thou wilt be passing fair as a queen, Salome."

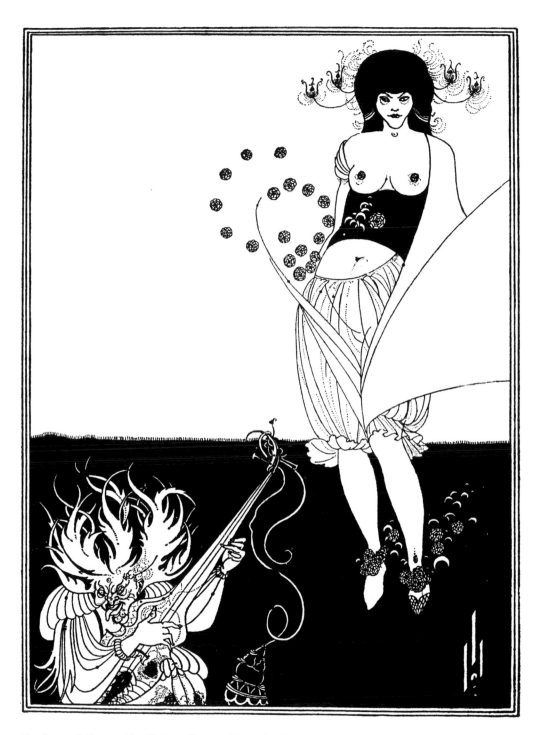

The Stomach Dance: "I will dance for you, Tetrarch…" 41

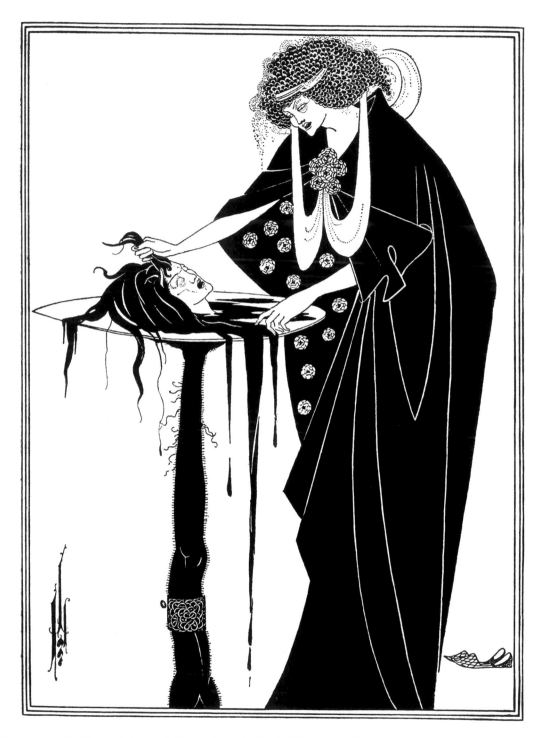

42 The Dancer's Reward: "I ask of you the head of Iokanaan…"

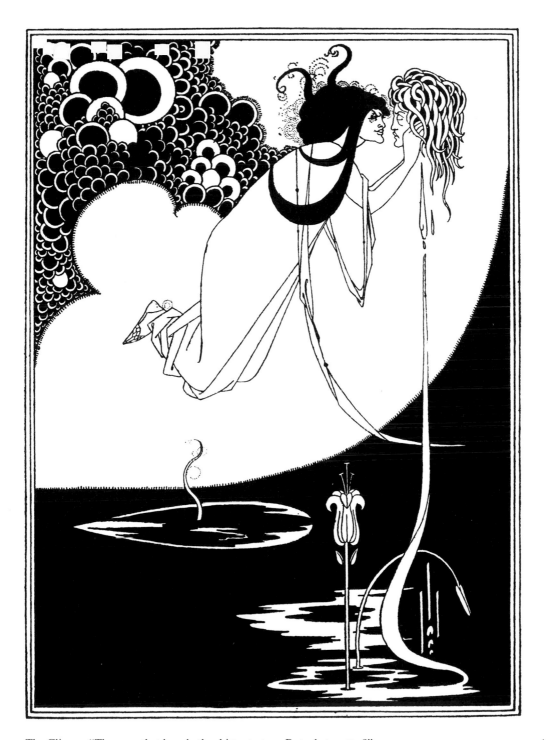

The Climax: "They say that love hath a bitter taste… But what matter?"

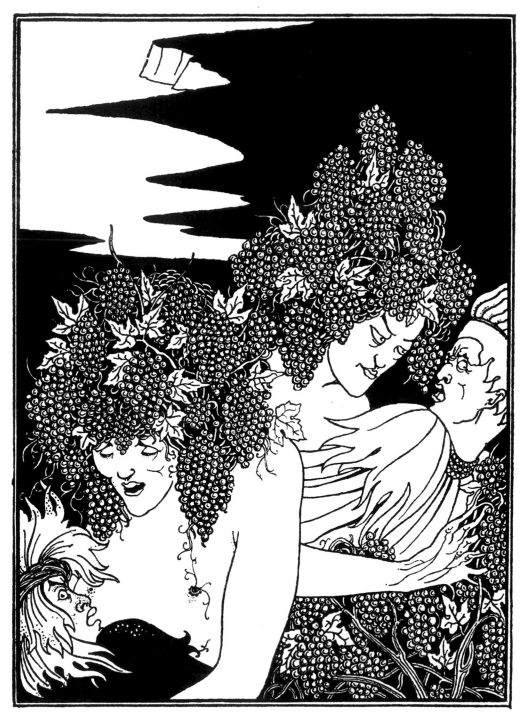

44 Two designs entitled A Snare of Vintage, for *Lucian's True History*. In this fantastic tale by the Greek writer, Lucian (second century), the vines are man-eating femmes fatales…

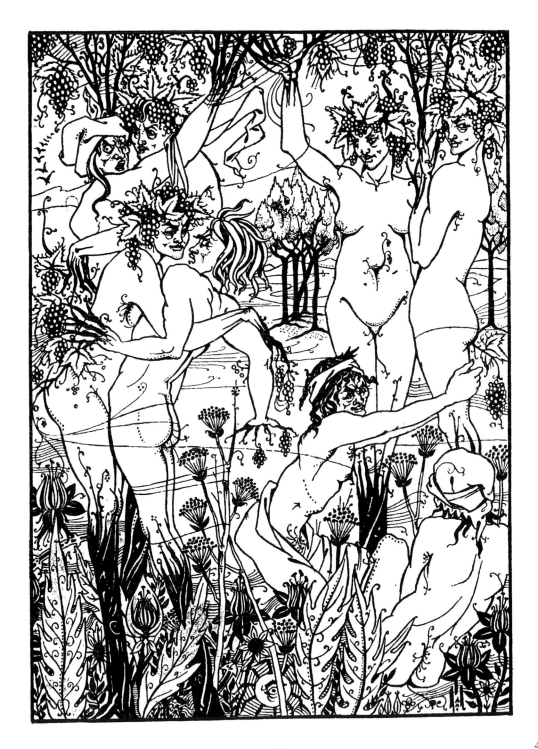

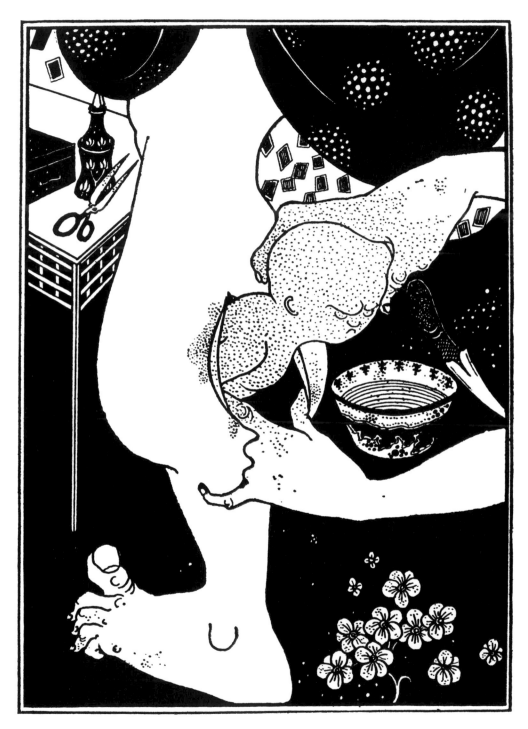

46 Lucian's bizarre tale is full of strange creatures and foetuses born from the calf of the leg…

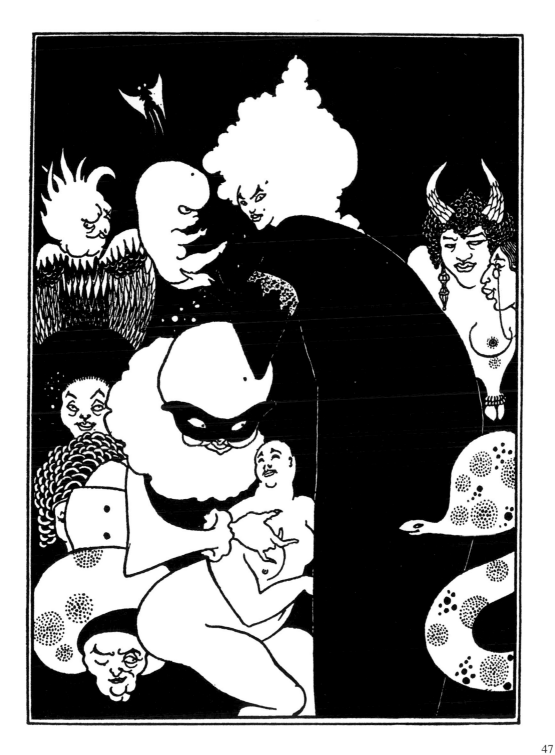

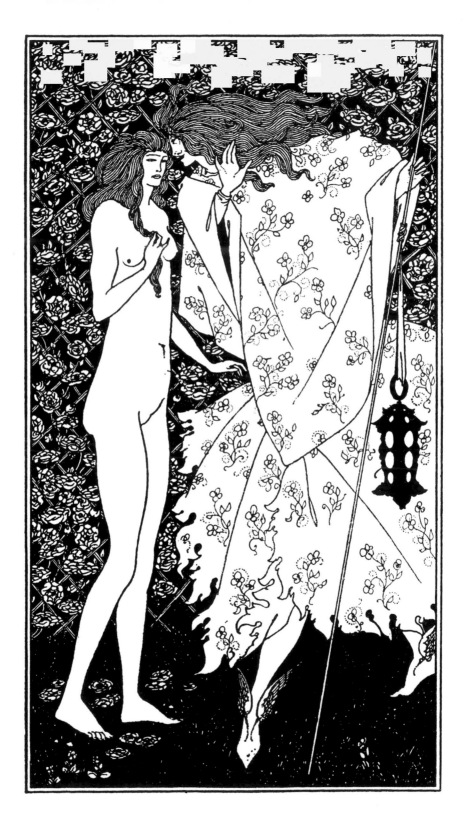

After *Salome*, Beardsley turned his back on Wilde's biblical world and the distant Middle Ages to devote himself again to his particular vision of life, art and literature, moving on to the next phase of his short career: *The Yellow Book* period. Beardsley came up with the idea for what he described as a "new literary and artistic Quarterly" with his friend Henry Harland, an American writer living in London, and John Lane agreed to publish it. Beardsley explained his aim as follows: "Our idea is that many brilliant story painters and picture writers cannot get their best stuff accepted in the conventional magazine, either because they are not topical or perhaps a little risqué". From the start, the new magazine provoked a general outcry, but Beardsley, until then known only in London's artistic circles, became a household name. Beardsley's drawings, executed in the same vein as those by Toulouse-Lautrec, depicted the London demimonde, its wealthy and monstrous inhabitants (p. 50), its hidden vices (p. 53), the corruption, idleness and luxury enjoyed by a certain class of young people (p. 52), or the initiation of a young, seemingly innocent girl into the understanding of good and evil by a corrupting influence (*The Mysterious Rose Garden*, p. 48), a theme that, in a more rural version, depicted her instructor as a faun with cloven hooves (p. 17).

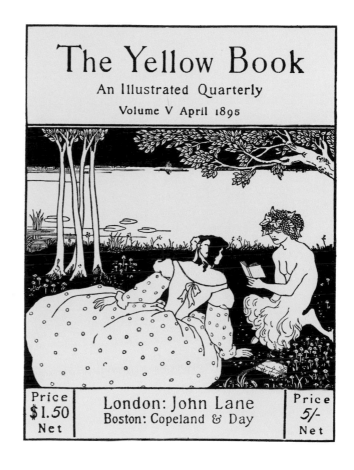

Prospectus for *The Yellow Book*, 1895

Left: The Mysterious Rose Garden, 1894. First version, before the Prospectus (p. 17), depicting the revelation of good and evil to a supposedly innocent young girl (p. 50)

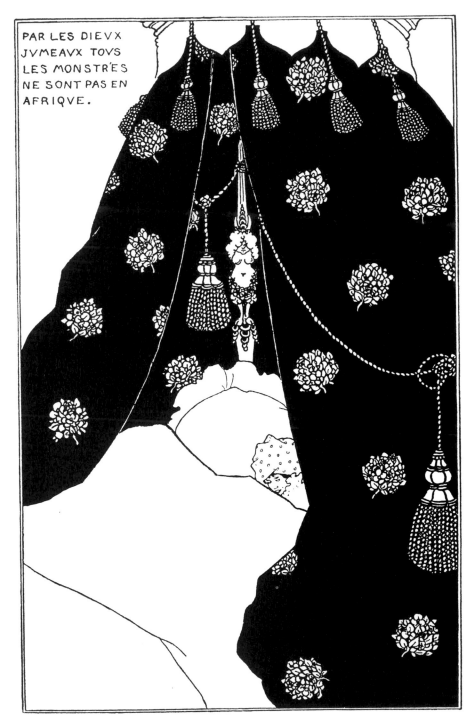

50 Beardsley's Portrait of Himself in Bed for *The Yellow Book*, 1894: "…not all the monsters are in Africa"

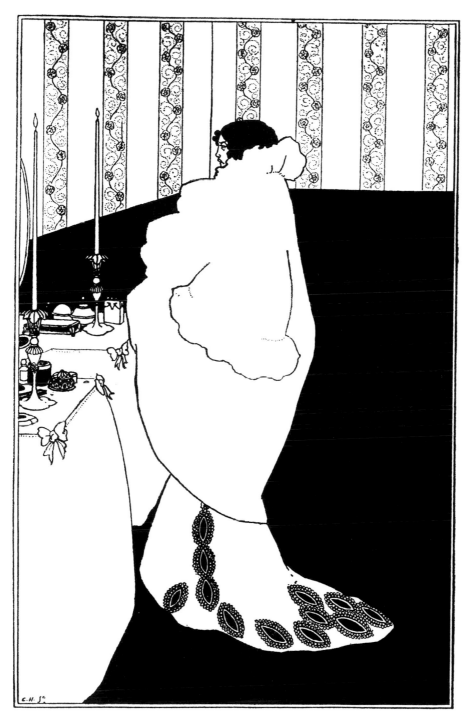

La Dame aux Camélias, for *The Yellow Book,* Vol. III, 1894:
Beardsley was very fond of the novel by Dumas fils

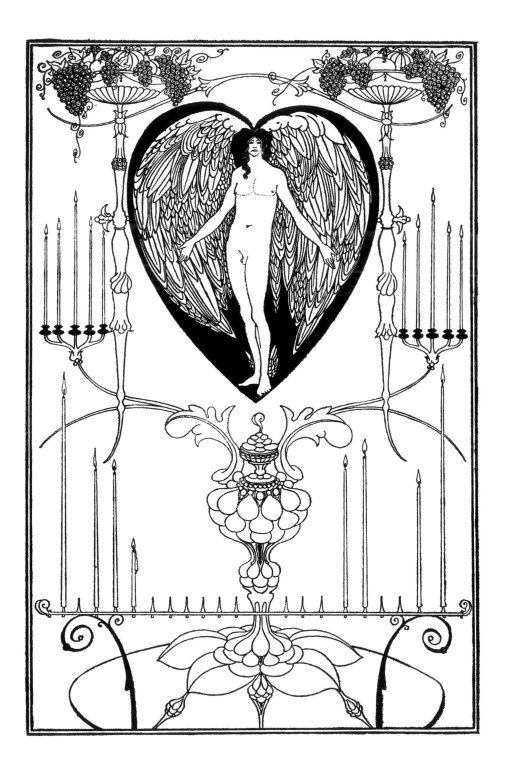

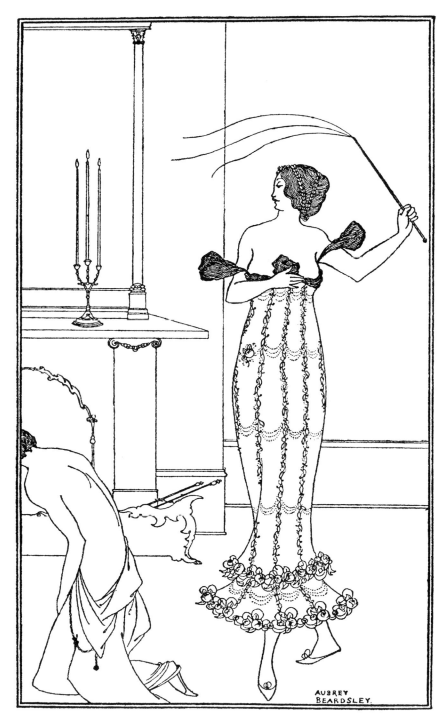

Two frontispieces, dated 1895, both depicting the secret vices of Victorian high society. The Wonderful Mission of Earl Lavender, Which lasted One Day and One Night. Left: The Mirror of Love

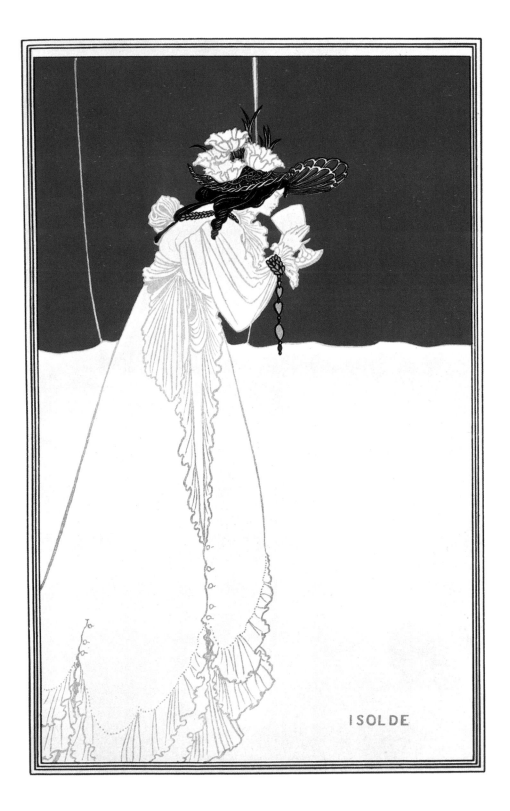

ISOLDE

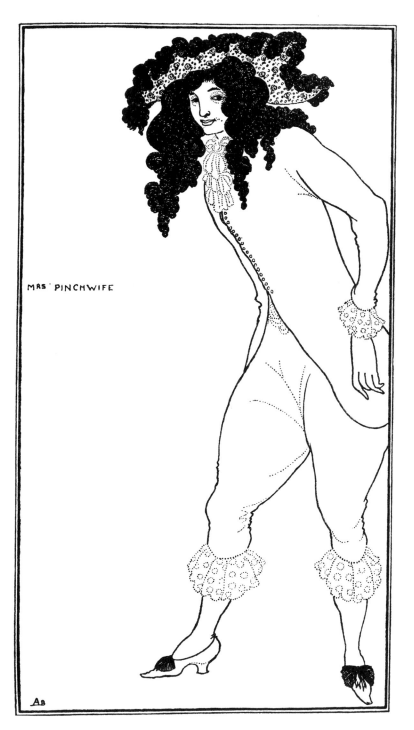

MRS PINCHWIFE

Two types of woman according to Beardsley: dressed as a man, Mrs Pinchwife, design for a novel, 1896. Left: Isolde, about to drink her love drink, for *The Studio*, 1895

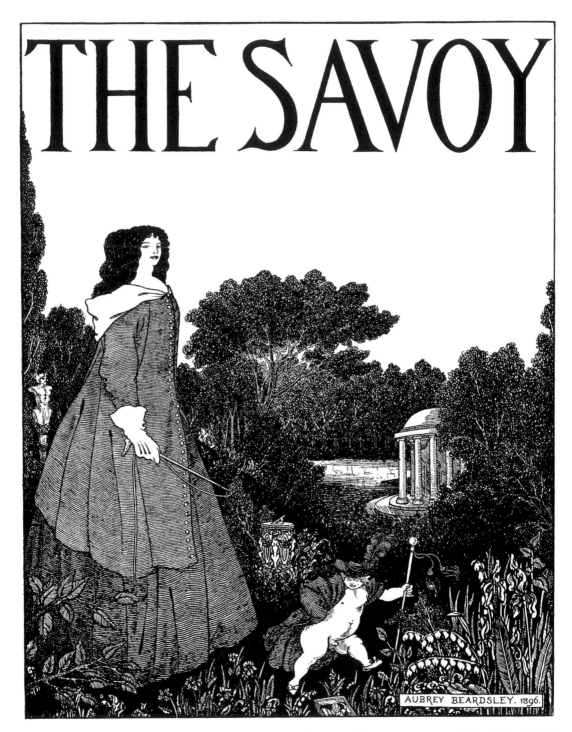

Drawing for the cover of *The Savoy* No. 1, with a putto urinating over a copy of *The Yellow Book* in the foreground, 1895

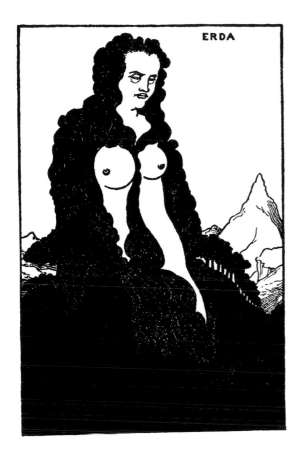

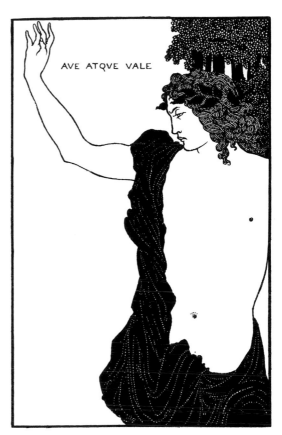

The Savoy

Dismissed from *The Yellow Book*, Beardsley took his revenge by launching a rival magazine with his friend Smithers, a publisher of erotic literature and avant-garde works. This magazine, *The Savoy*, which contributed to the success of Art Nouveau in Great Britain, printed *Venus and Tannhäuser* (p. 58), a book for which he provided both text and illustrations. Beardsley's drawings for *The Savoy* marked a new stage in his stylistic development. He began to take eighteenth-century France as his model, drawing his inspiration from prints by Watteau or various rococo artists of whom he possessed several engravings. He also revenged himself with his original drawing for the cover of *The Savoy No. 1* (p. 56) which shows, in the foreground, a well-endowed, chubby putto urinating over a copy of a magazine that, in all likelihood, is *The Yellow Book*. This superb pastoral drawing also shows the influence of another French painter, Claude Lorrain, a seventeenth-century artist whom Beardsley greatly admired.

Left: Erda, illustration for *Das Rheingold, The Savoy* No. 8

Right: Ave Atque Vale, 1896. Drawing for *The Savoy* No. 7 illustrating the words by the Latin poet Catullus, or Beardsley's own leave-taking: Hail and Farewell…

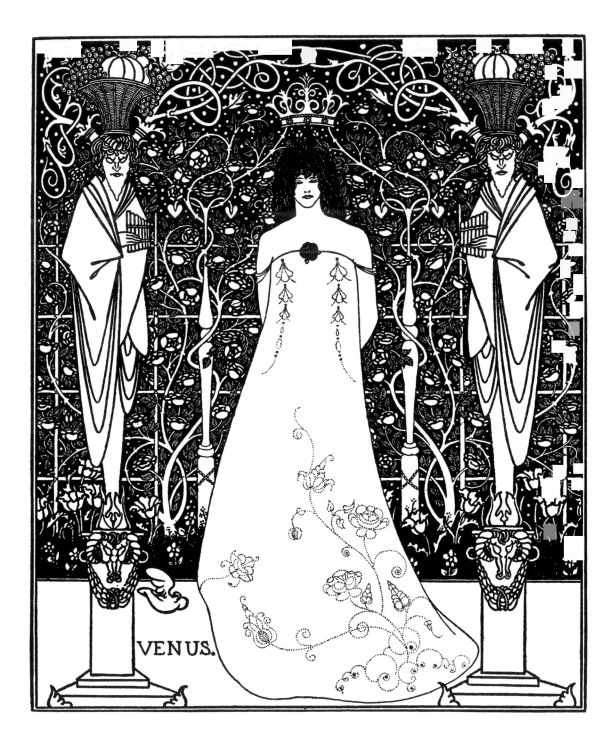

VENUS.

Frontispiece for *Venus and Tannhäuser*, 1895

Venus and Tannhäuser

The story of Venus and Tannhäuser gave Beardsley the chance to indulge his literary pretensions. He did not have time to complete it and was still working on it shortly before his death. As it stands, this short story is a small masterpiece of Decadent art. Only part of it was published in *The Savoy*. Smithers published the complete unexpurgated version in 1907. It was such a *succès de scandale* that it swiftly became unobtainable. There have been many reprints, including one in France by the Presses Olympia in 1959. Beardsley's originality resides in the tension between a mass of stylised and intricate detail and vast expanses of white. *The Abbé* (p. 62) is one of the finest gems of this rococo style. Beardsley changed the title of his romantic story to *Under the Hill*, while Tannhäuser became the delightful Abbé Fanfreluche, a name echoing eighteenth-century France that was finally altered to Abbé Aubrey, clear proof that Beardsley identified closely with the character. As Simon Wilson points out, "As such it reminds us that Beardsley, like many of the great Romantics and Decadents, from Gautier and Baudelaire to Whistler and Wilde, was a tremendous dandy as can be seen from the marvellous portrait of him by Jacques-Emile Blanche in the National Portrait Gallery, London." (p. 93). *Das Rheingold* is one of Abbé Fanfreluche's bedside books, a work that Beardsley would have liked to illustrate (p. 63), had he not lacked the time to complete this project.

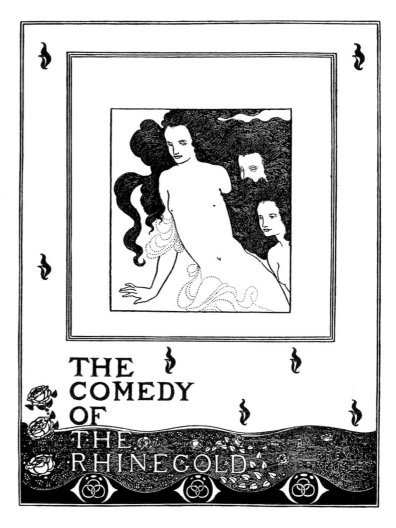

Frontispiece for *Das Rheingold*, 1896. At the same time as writing his *Tannhäuser*, Beardsley was keen to turn Wagner's opera into a comedy.

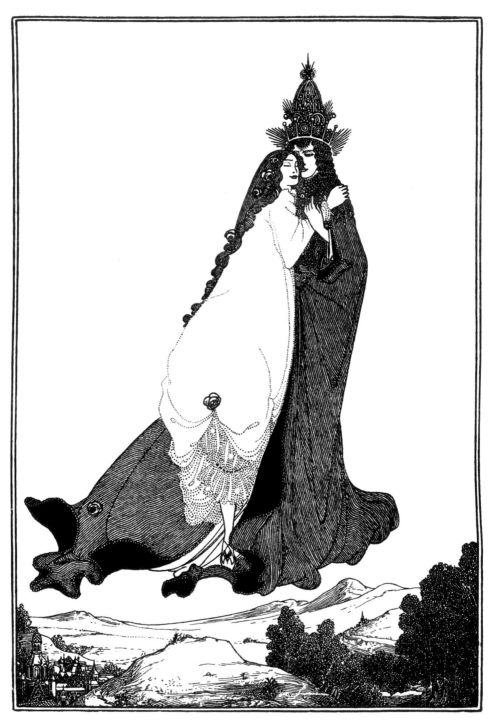

60 The Ascension of St Rose of Lima, 1896. Religious transposition of Tannhäuser rising above the earth

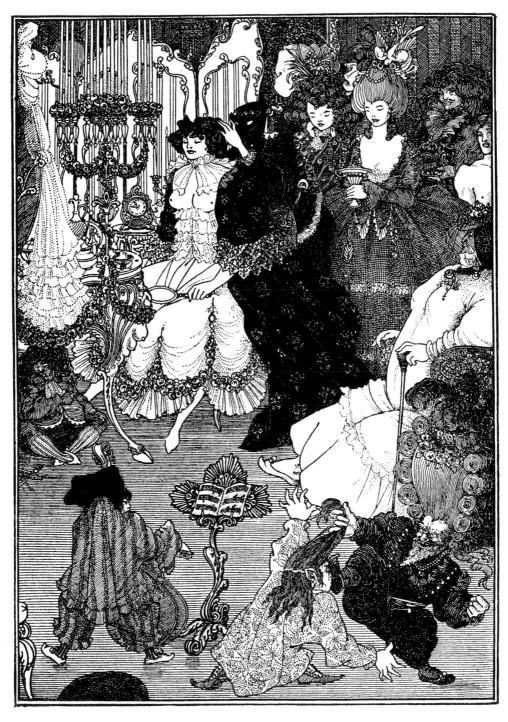

The Toilet of Helen, 1895. Another woman at her toilet, surrounded by Beardsley's beloved monsters. Helen was another name he gave to Venus.

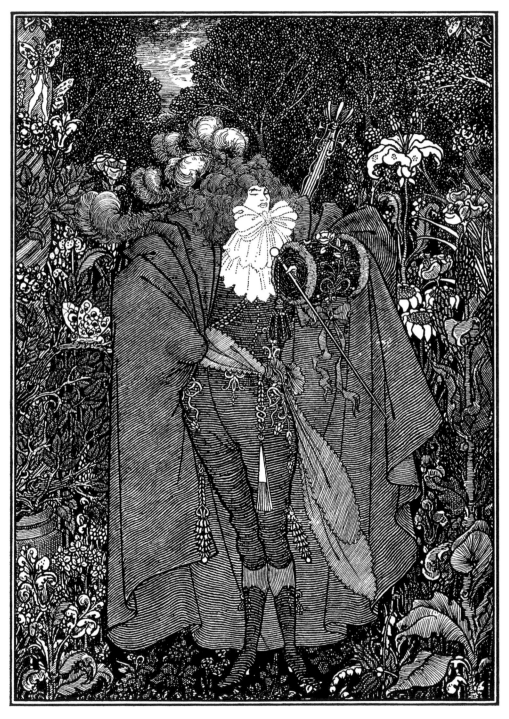

62 The Abbé, 1895. The ineffable Abbé Fanfreluche, alias Abbé Aubrey, a portrait of the author as a decadent and debauched dandy…

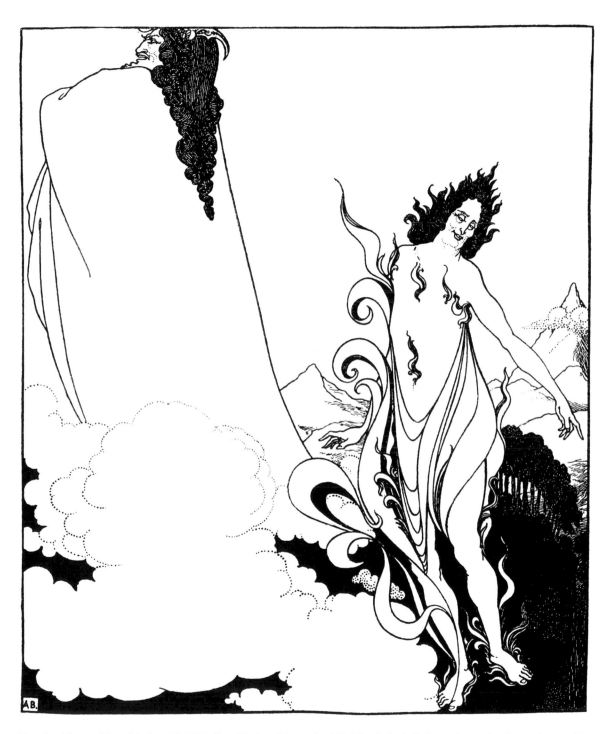

Fourth tableau of *Das Rheingold*, 1896. *Das Rheingold* was the Abbé Fanfreluche's favourite book. The curl- 63
ing flames are a wonderfully innovative visual design unprecedented in European art. The drawing was used
for the cover of *The Savoy* No. 6.

The Rape of the Lock

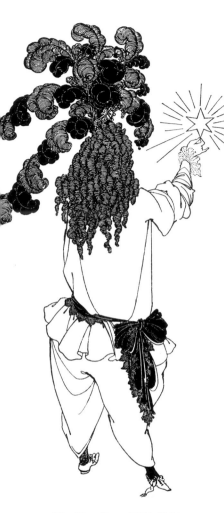

Beardsley's third masterpiece was his illustration of *The Rape of the Lock* by Alexander Pope, a commission bound to appeal to him because Pope's work, baroque, satirical and whimsical, with erotic overtones, reflected Beardsley's tastes, and was in keeping with his recent passion for the eighteenth century. The entire story revolves around the lock of hair stolen from Belinda, the heroine, by a daring baron, struck by its brilliance, who decides to build an altar to it along side three garters, one glove and other similar trophies from previous love affairs; an altar to which he sets fire when burning his billet-doux. This is a thoroughly decadent and fetishist theme. The lock of hair escapes the flames, wafting heavenwards to become a new star in the firmament. Belinda's fury at the theft (p. 68), gives Pope and Beardsley the opportunity to portray *The Cave of Spleen* (p. 65), personified as a goddess of wrath: "Here stood *Ill-nature* like an *ancient Maid,*/ Her wrinkled Form in *Black and White* array'd;" while "A constant *Vapour* o'er the Palace flies;/ Strange Phantoms rising as the Mists arise."

The New Star, 1895–1896

The Billet-Doux, 1895–1896

Two illustrations for *The Rape of the Lock* (Smithers, 1896)

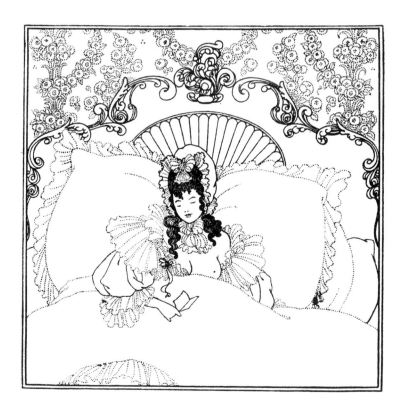

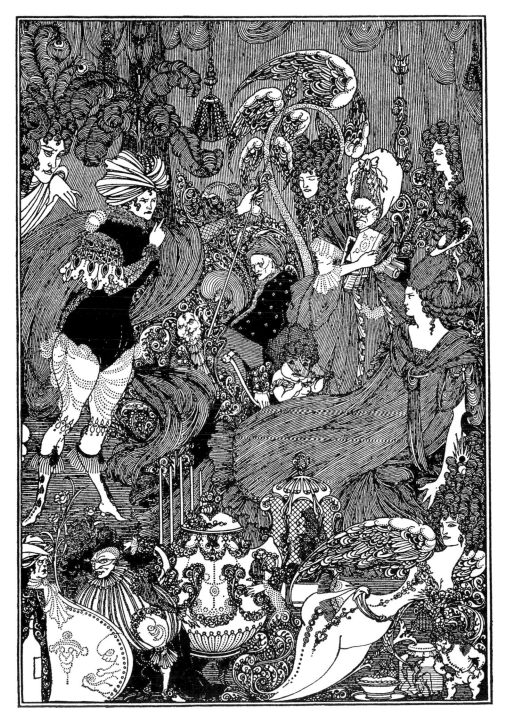

The Cave of Spleen, 1896. The baron has succeeded in stealing a lock of hair from Belinda, the object of his desire. This is the result of her wrath…

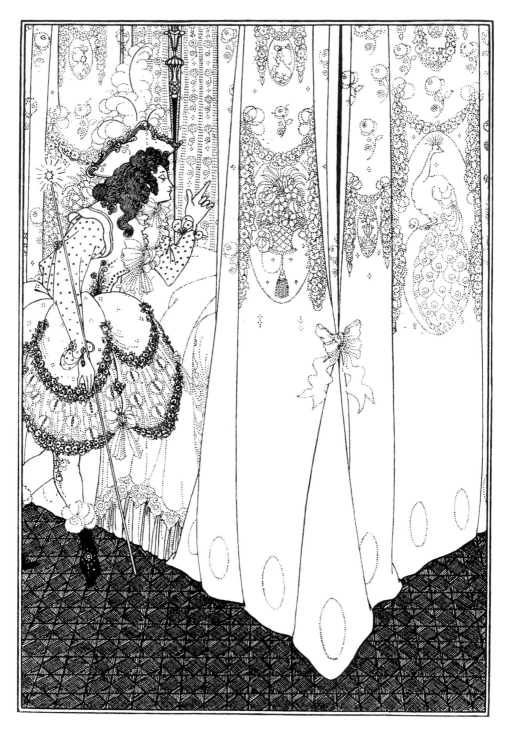

66 The Dream, 1895–1896. The voyeuristic baron lusting after a lock of the sleeping Belinda's hair.

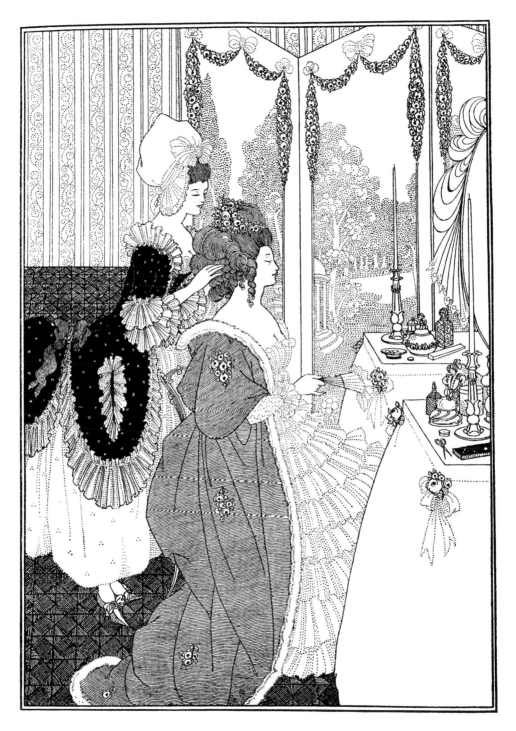

The Toilet… 1895–1896. A theme that Beardsley particularly favoured

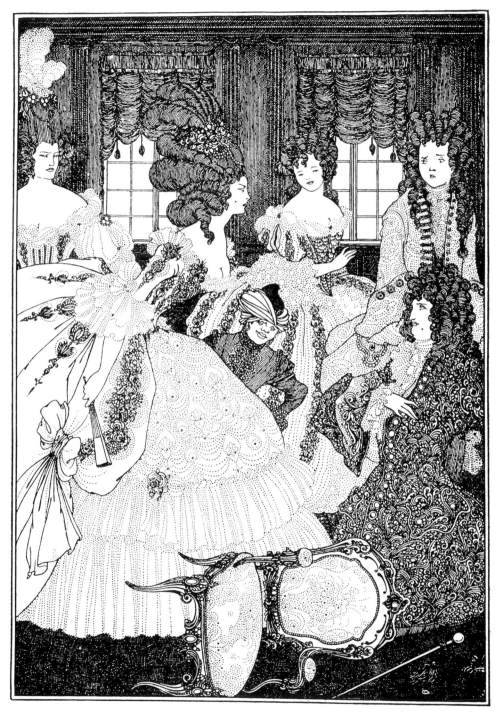

68 The Battle of the Beaux and the Belles, 1895–1896. Belinda throws snuff in the baron's face when he refuses to give back her lock of hair. Beardsley had never before produced such elaborately detailed work or experimented so extensively with the balance between light and dark.

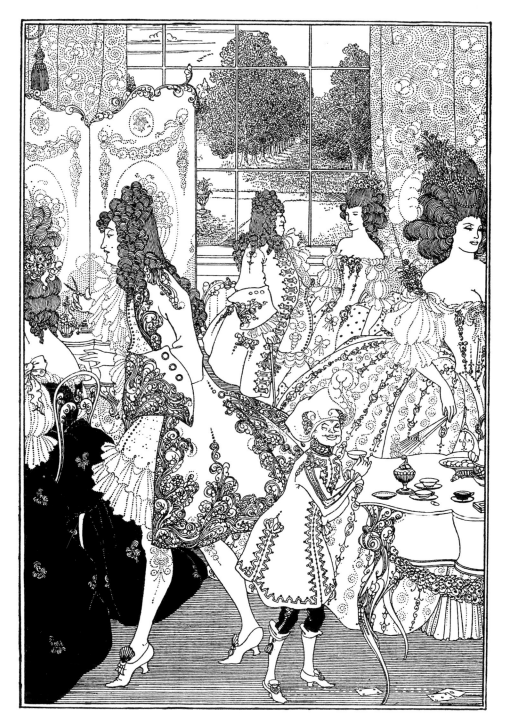

The Rape, 1895–1896. The baron's crime and his wicked scissors…

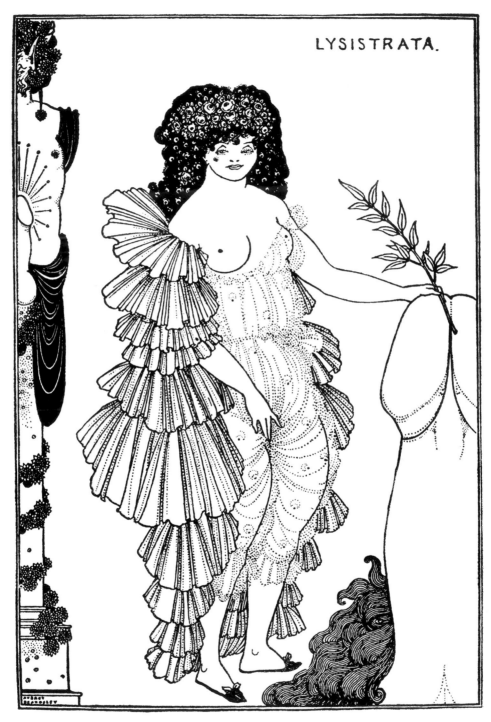

LYSISTRATA.

70 Frontispiece for Aristophanes' *Lysistrata*, 1896. Lysistrata offers an olive branch to her foe: the penis…

Lysistrata

Immediately after finishing work on *The Rape of the Lock*, Beardsley started, at Smithers' request, to illustrate *Lysistrata* by Aristophanes (c.450–386 BC), the most famous Athenian comic poet. In the play, the women of Athens and Sparta, led by Lysistrata, a remarkably modern female leader, decide to withhold sex from their husbands and lovers as long as they continue to do battle. A bawdy and amusing solution that does not lack relevance to present-day issues. Beardsley indulged himself to his heart's content, creating his most overtly erotic work. Abandoning the intricate style of *The Rape*, he returned to the elegance and linear purity of *Salome*, placing even greater emphasis this time on the importance of outline. Each memorable figure was drawn against a completely white background. This work is a true tour de force that bears witness to Beardsley's continual artistic development from book to book. Like a cartoon strip, Beardsley's illustrations show by turns the female leader, Lysistrata (p. 70), resting on her main argument. She harangues her troops of women (p. 72) and locks herself with them in the Acropolis from where they repel the men's attacks by means of numerous gambits such as farting and showering them with the contents of their chamber pots (p. 73). Sexual abstinence soon becomes unbearable for their warrior husbands who no longer know what to do with their enormous members

Cover for *Lysistrata*, 1896

(p. 74) and finally exchange ambassadors (p. 75). Cinesias, one of the leaders, returning from war tormented by desire and "writhing in Aphrodite's love-grip" implores his wife Myrrhina to take pity on him. But she, following Lysistrata's orders, rejects him, leaving him in such a state of arousal that he is prepared to do anything, even sign a peace treaty with Sparta (p. 76). Naturally, there are deserters who, in their frustration, try to escape to visit the enemy, one by descending a rope, the other trying to flee with the help of a bird (p. 77).

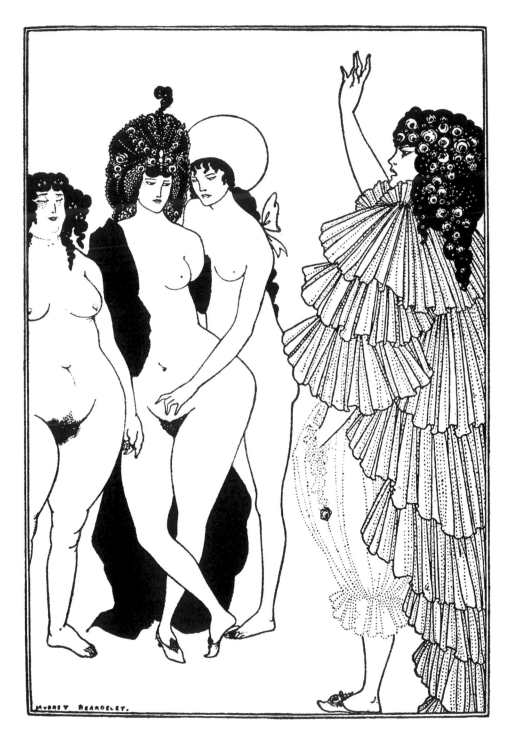

Lysistrata Haranguing the Athenian Women

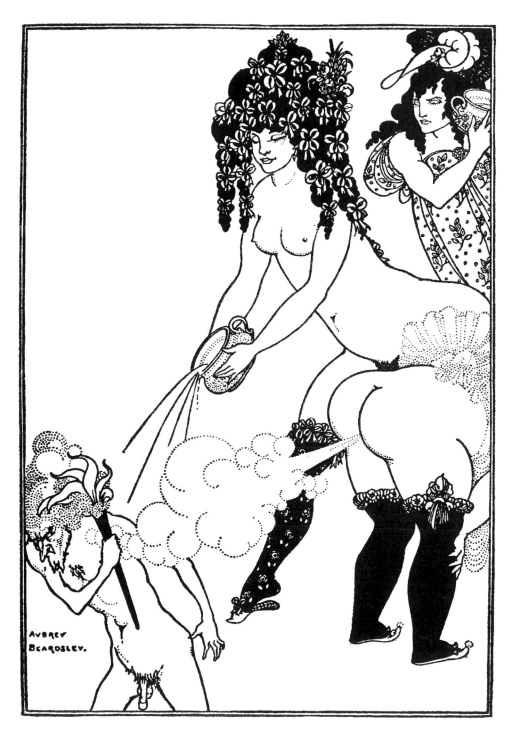

Lysistrata Defending the Acropolis

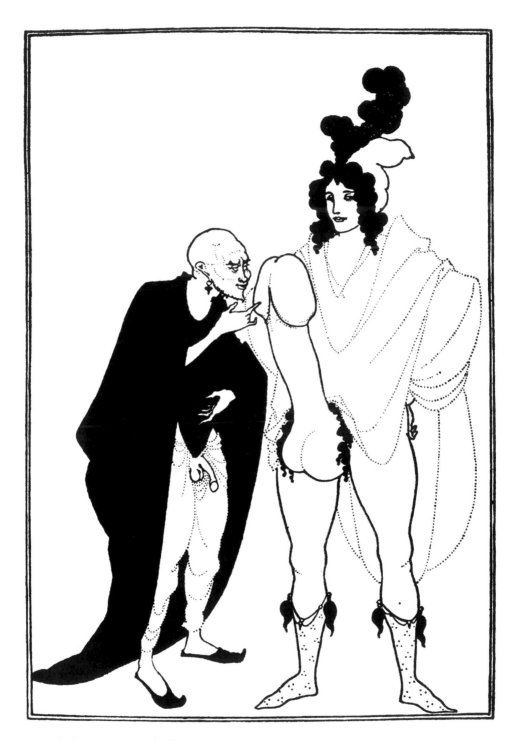

The Examination of the Herald

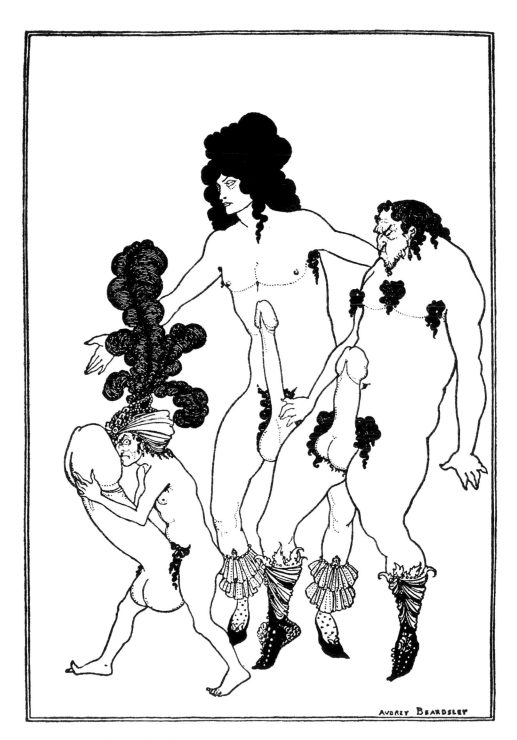

The Lacedaemonian Ambassadors

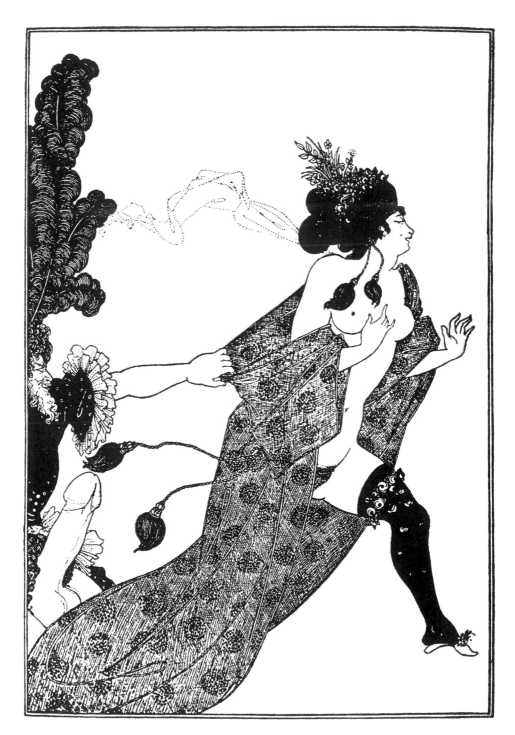

76 Cinesias Entreating Myrrhina to Coition

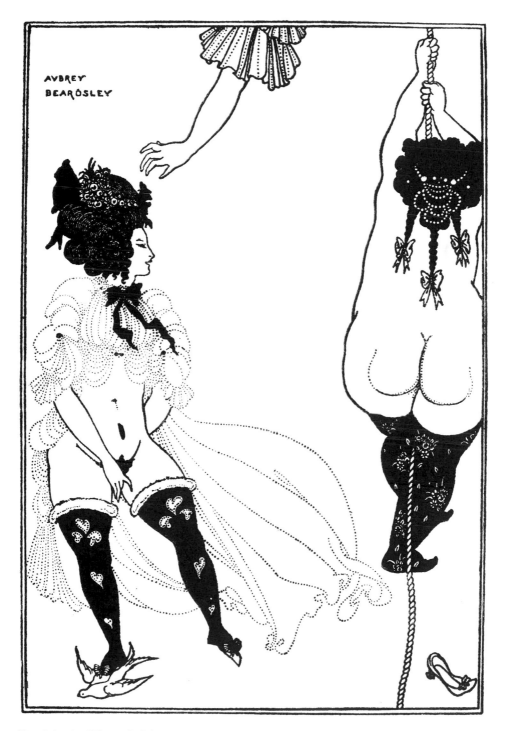

Two Athenian Women in Distress

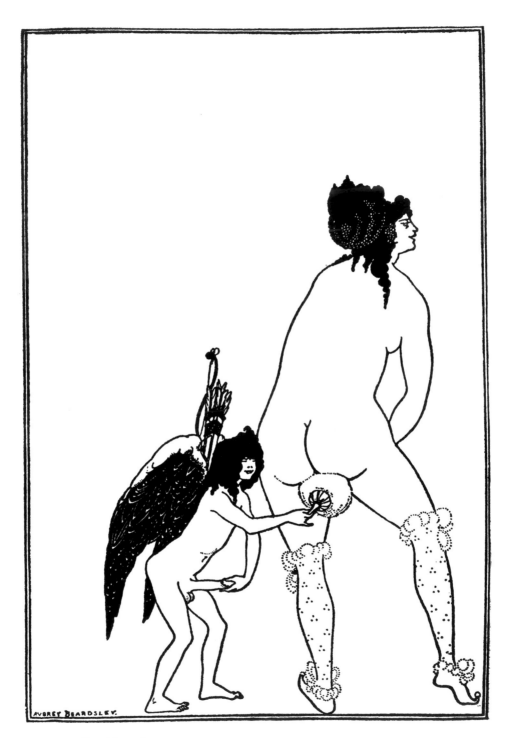

78 The Toilet of Lampito

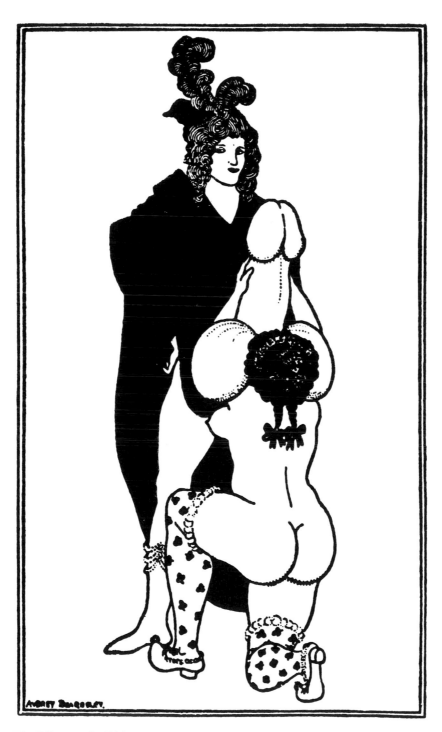

The Yellow Book, 1894 or The Importance of Size…

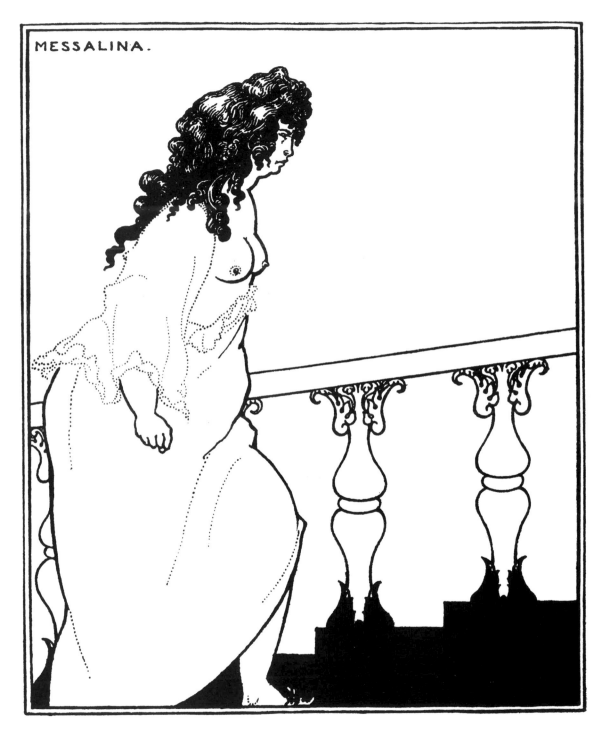

MESSALINA.

Messalina Returning from the Bath, 1897. Beardsley drew 5 designs for Juvenal's *Six Satires*.

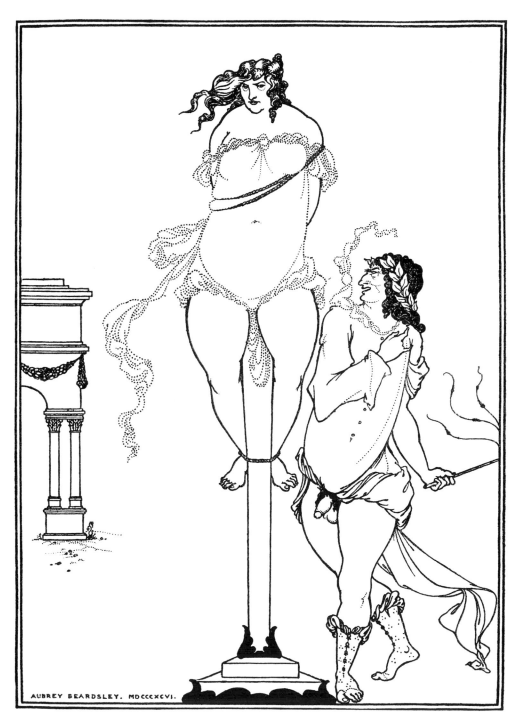

Juvenal Scourging a Woman, 1897. Like that of Messalina, this drawing mirrors the hidden vices
of hypocritical Victorian high society

Lysistrata's plan eventually works, the ambassadors sign a peace treaty, and the sex life in Greece is heartily resumed. *Lysistrata* is the last of Beardsley's masterpieces. The artist continued, however, between two bouts of illness, to execute several isolated masterpieces, but all his projects remained unfinished. However, after *Lysistrata*, he began, in the same vein, to illustrate the *Six Satires* by the Latin poet Juvenal (c. 60–128). Juvenal's fierce denunciation of the immoral behaviour of the patricians of his period struck a chord with Beardsley who also wanted to denounce the hypocrisy and loose morals of Victorian women. *Messalina* (p. 80), famous for her life of debauchery, presides like a London whore over a brothel under the name of Lycisca, the wolf-girl, before returning to the palace of her husband, emperor Claude I, still frustrated, as can be seen by her clenched fist and disappointed expression:

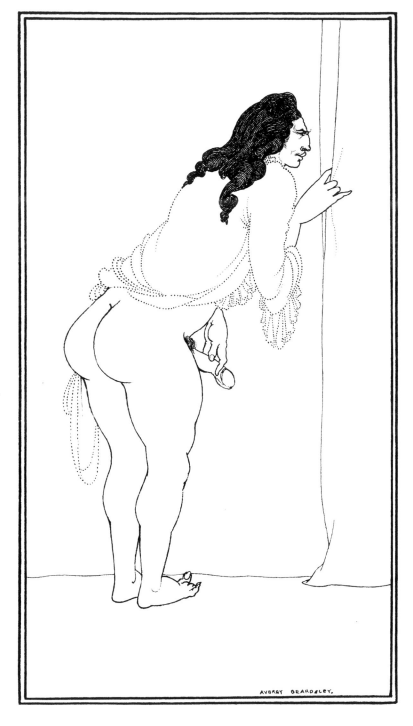

The Impatient Adulterer, 1897. A brothel client waiting his turn while indulging in a little voyeuristic pleasure. Beardsley's 'naughty' drawings were becoming increasingly indecent…

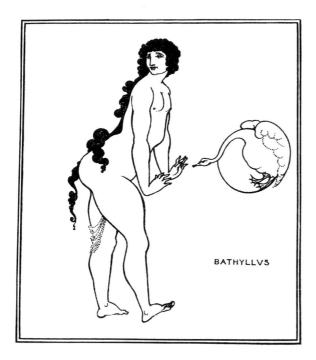

BATHYLLVS

"Fatigued by men and not yet sated, she returned / In her dark cheeks deformed, and foul with the smoke of lamps, / Brought to the couch divine the odour of the stews." (Juvenal, *Satire VI*). *Juvenal Scourging a Woman* (p. 81) is familiar in concept to the drawing on page 53: both reveal the existence of sects frequented by the well-to-do Victorian classes – like the *Flagellant Society* in London – who, indulging in a life of luxury and idleness, secretly flouted the traditional values they hypocritically claimed to uphold. Beardsley's "naughty" drawings became increasingly indecent, so much so, in fact, that he could no longer sell them to his collector friends. This was the case for the last ones he drew for Satire VI: *The Impatient Adulterer* (p. 82), or the one modelled on Greek vases that he devoted to *Bathyllus* (p. 83), the debauched, effeminate dancer of the decadent Roman period.

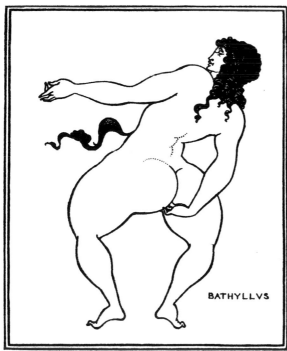

BATHYLLVS

Bathyllus in the Swan Dance (top) and Bathyllus Posturing (bottom), 1897. Two designs inspired by Juvenal's description of the debauched, effeminate dancer of the decadent Roman period

Ave Atque Vale

During the last fifteen months of his short life, Beardsley tackled a variety of projects and continued to create several tours de force that bear witness to his unstoppable creativity. *The Black Cat* (p. 85), for Edgar Allan Poe's *Tales,* is probably one of his most striking drawings, both from a strictly formal point of view and because of his masterly use of black and white. To depict the black cat against a black background, he simply reversed the traditional technique to create a contrast for each of the two figures: a simple white line for the ominous bulk of the cat, extreme whiteness to convey the woman's corpse-like pallor, appropriate as Poe was referring to death in his tale. There is the same expressive and effective mastery of blacks and whites in *Les Liaisons Dangereuses* (p. 86), *Apollo Pursuing Daphne* (p. 87) which is unfinished, but displays a skilful hint of eroticism and *Ali Baba* (p. 88) superbly portrayed as a complacent mountain of flesh, covered with sparkling jewels after seizing the treasure of the forty thieves. The lavish effects were created, once again, simply by exploiting the contrast between blacks and whites. *The Lady with the Monkey* (p. 89) bears witness to another abortive project, the illustration of *Mademoiselle de Maupin,* by Théophile Gautier, an important book both for the Romantics and for the Decadents.

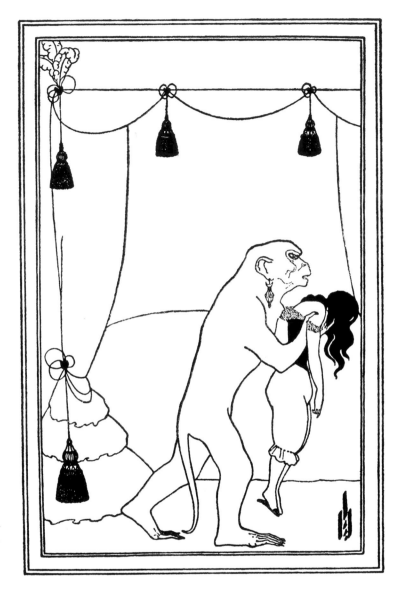

Illustration for *The Murders in the Rue Morgue,* one of Edgar Allan Poe's *Tales,* 1895

Right: *The Black Cat,* illustration for the tale by Edgar Allan Poe, 1894. Beardsley intended to make 8 drawings, but only had time to finish 4.

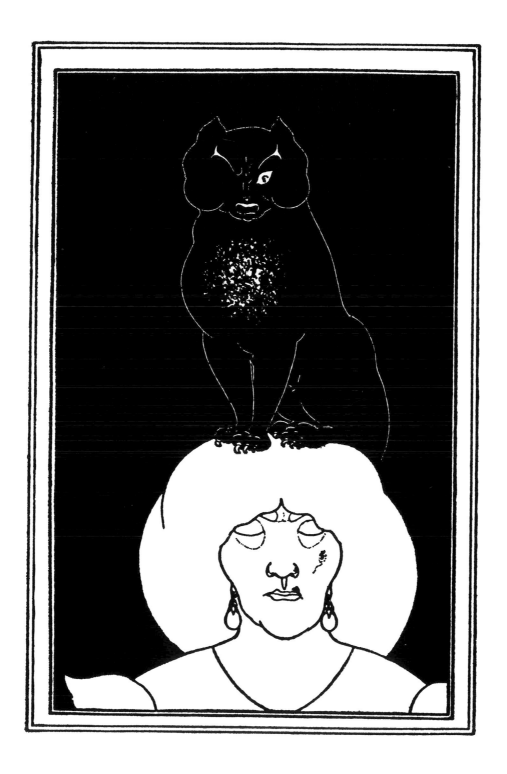

Count Valmont, 1896. Title-page for *Les Liaisons dangereuses* by Choderlos de Laclos.

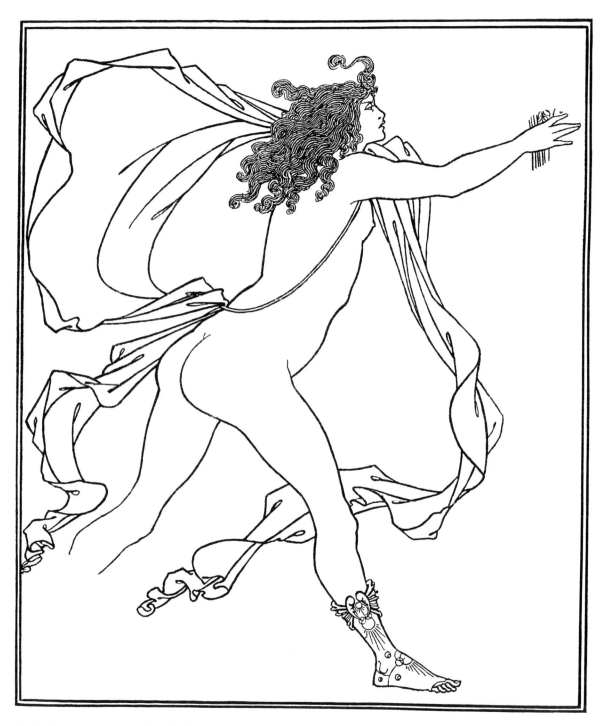

Apollo Pursuing Daphne, 1896. Unfinished drawing executed at the same time and in the same style as *Lysistrata*.

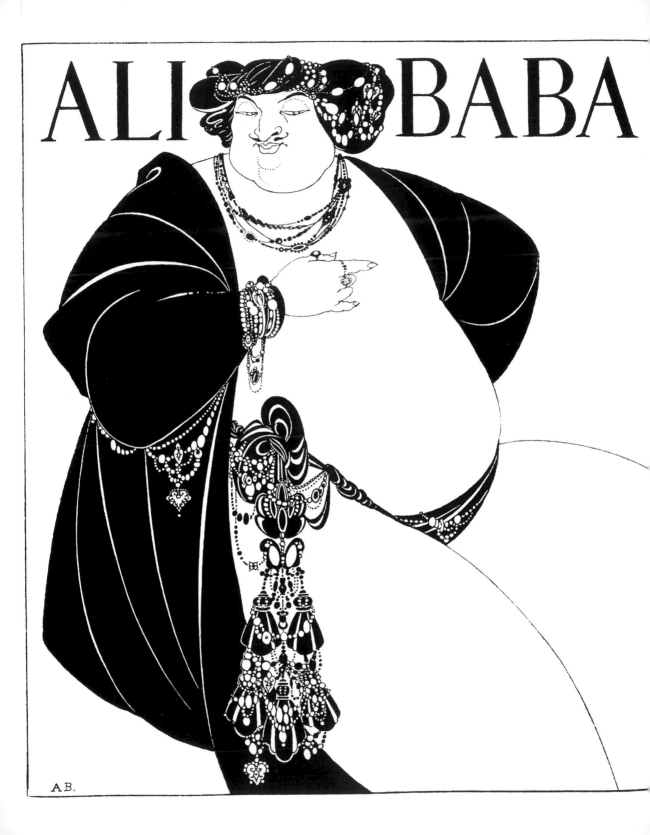

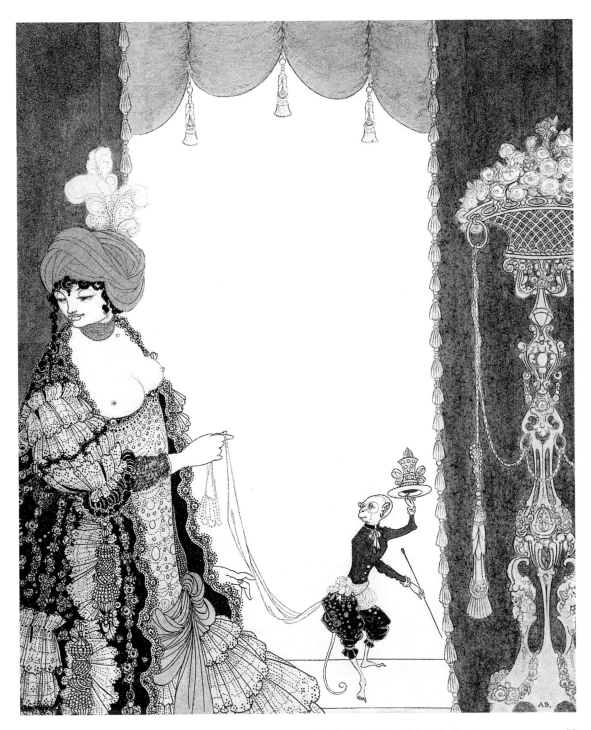

The Lady with the Monkey, 1897. Illustration for *Mademoiselle de Maupin* by Théophile Gautier

Left: *Ali Baba*, 1897

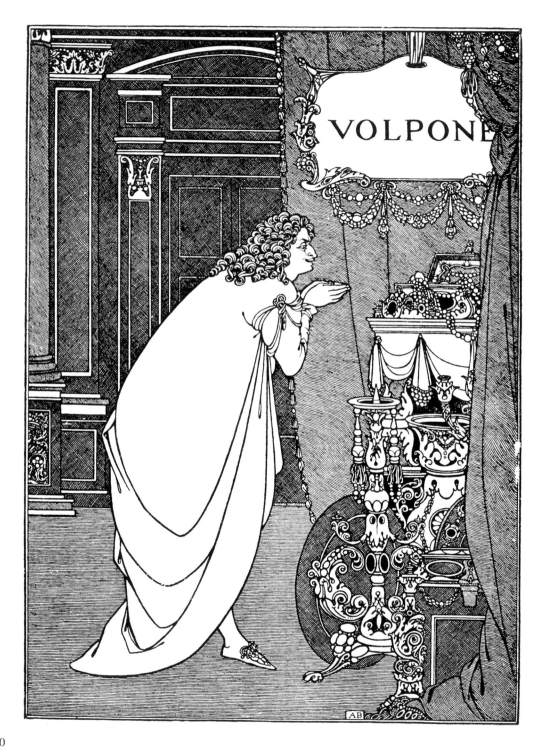

VOLPONE

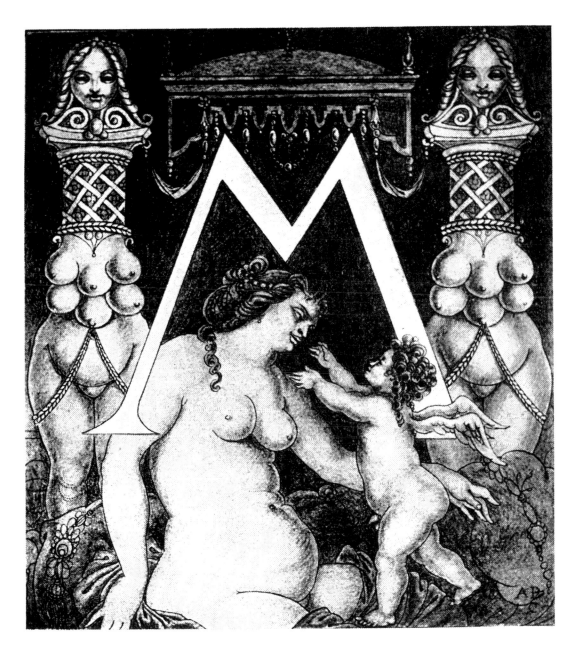

Finally, *Volpone*, (p. 90), in jubilant contemplation of his ill-gotten gains, and several erotic initials (p. 91) were Beardsley's last works.

But his final artistic statement, through which he expressed his awareness of imminent death, had already been published in 1896 in

The Savoy No. 7: Ave Atque Vale (p. 57) meaning: Hail and Farewell.

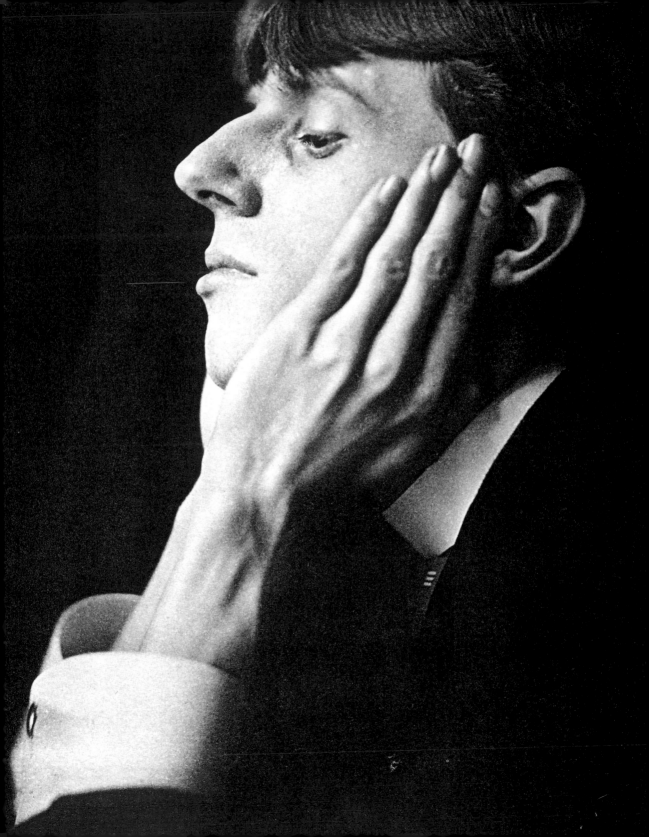

AUBREY BEARDSLEY.

1872 Aubrey Vincent Beardsley was born in Brighton on 21 August. His father, Vincent Beardsley, squandered the family fortune. His mother, Ellen Agnes Pitt, from a wealthy middle-class family, worked as a governess and music teacher.

1879 Thanks to his mother, Aubrey had by the age of seven acquired an unusually wide literary education and seems to have been a musical prodigy. He was sent to a boarding school south of Brighton, a place chosen for the quality of its air because Aubrey was already showing early symptoms of the tuberculosis that would bring about his untimely death.

1881 Aubrey's health caused his mother to move to Epsom. A family friend, Lady Henrietta Pelham, bought his first drawings copied from illustrations by Kate Greenaway.

1884 After a stay in London, the family went back to live in Brighton with Sarah Pitt, a wealthy relative, who financed his studies at Brighton Grammar School.

1888 At Brighton Grammar School, one of his teachers, Arthur William King encouraged him, publishing his drawings in the school magazine. Together, they organised theatre and opera performances. He illustrated a programme and designed the costumes of a comic opera, *The Pay of the Pied Piper*.

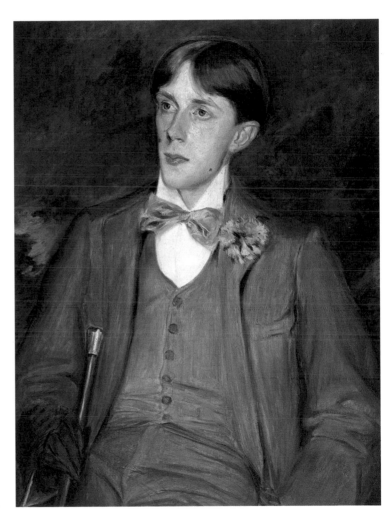

Jacques-Emile Blanche (1862–1942): Aubrey Beardsley, oil on canvas, 1895, or the portrait of a dandy… National Portrait Gallery, London

Left: Beardsley photographed in 1894 by Frederick Evans (1853–1943)

1889 He left school and moved to London where he secured a post at the *Guardian Insurance Company* in the City.

1890 The *Arts and Crafts Movement*, whose books were printed in colour from wood cuts using a technique developed in 1865 by Walter Crane, had a profound influence on him. He wrote to his teacher telling him that he was coughing up blood.

1891 A decisive visit to the studio of Edward Burne-Jones who was in 1861 one of the founder members of *Morris and Company*, and later a leading figure in the *Arts and Crafts Movement*. When he saw Beardsley's drawings, he exclaimed: "There is no doubt about your gift, one day you will most assuredly paint very great and beautiful pictures". He also helped him to find a good school: the *Westminster School of Art* run by the English Impressionist painter Frederick Brown.

1892 Beardsley visited Paris for the first time where he met Puvis de Chavannes, then President of the Salon des Beaux-Arts, who also encouraged him. In London, he was introduced to the publisher J. M. Dent, who commissioned him to illustrate *Le Morte Darthur* by Sir Thomas Malory. He also commissioned some small illustrations called *Grotesques* to decorate the volumes of *Bons Mots*, which were collections of the sayings and writings of the great wits of the past. This work enabled Beardsley to leave the insurance office for good.

1893 The publisher John Lane commissioned him to illustrate Oscar Wilde's play *Salome*, which kept him busy from the end of May

to the end of November and was a huge success.

1894 The English edition of *Salome*, with Beardsley's illustrations, caused a sensation. He also designed a controversial poster for the actress Florence Farr (p. 14). April saw the publication of the first issue of *The Yellow Book* of which Beardsley was art editor. The conservative press was up in arms, but Beardsley became a household name. He lived with his sister Mabel (which led to accusations of in-

cest) in a house which he bought in Pimlico and whose interior was described by William Rothenstein in his memoirs: "The walls were distempered a violent orange and doors and skirtings were painted black".

1895 The arrest and trial of Oscar Wilde caused him to be dismissed from *The Yellow Book*. He left for Paris. His friend Raffalovich provided moral support and financial help which he continued until his death.

1896 Taking his revenge on *The Yellow Book*, he joined forces with his friend Smithers to publish the first issue of *The Savoy* in January. This provided him with an income of £25 a week in return for the exclusive right to his work. He travelled widely: Cologne, Munich, Berlin, Dieppe… He wrote and illustrated *Venus and Tannhäuser* which he began to publish in *The Savoy* under the title of *Under the Hill*. He also started the drawings for *The Rape of the Lock* which he finished in Paris. In two months, June and August of the same year, he accomplished his final masterpiece, the *Lysistrata* illustrations for Smithers. Publication of the last issue of the *Savoy*.

1897 His tuberculosis worsened and he made his final drawings for Juvenal (*Six Satires*), Edgar Allan Poe (*Tales of Mystery and Wonder*), Choderlos de Laclos (*Les Liaisons dangereuses*), Théophile Gautier (*Mlle de Maupin*), Ben Jonson (*Volpone*) and *Ali Baba*… All these projects remained unfinished.

1898 In April he moved to Paris where he stayed until the autumn, then in November he travelled to Menton where he died during the night of the 15/16 March, at the age of twenty-five and six months.

Penrhyn Stanlaws: Portrait of Aubrey Beardsley, c.1890. This sketch shows the prints collected by the artist and the phallic candlestick given such prominence in his drawings

Right: William Rothenstein (1872–1945), drawing of Aubrey Beardsley, 1893

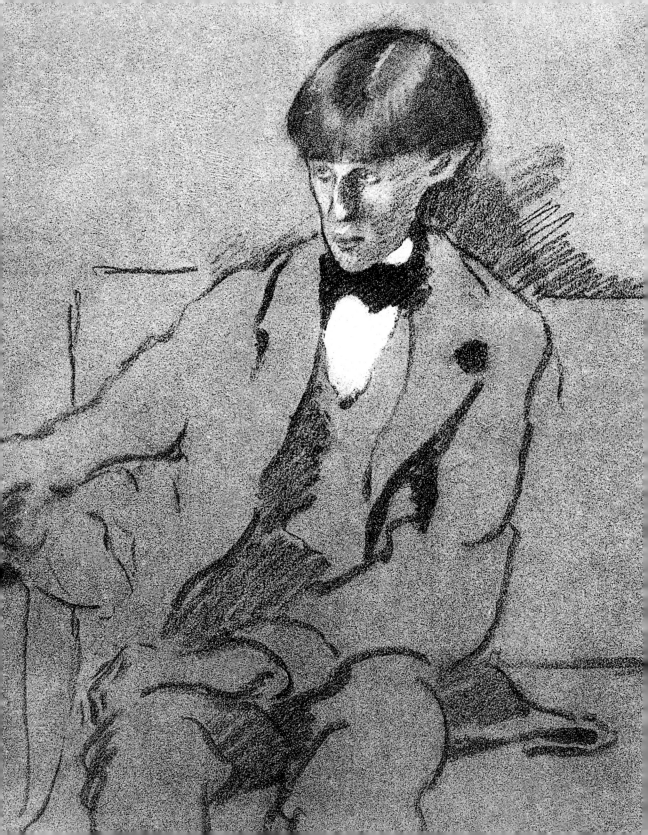

Vignettes drawn by Beardsley to illustrate the books in the *Bons Mots* series published by J. M. Dent in 1893

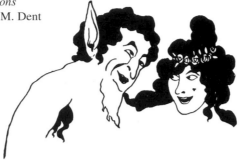

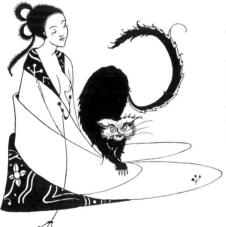

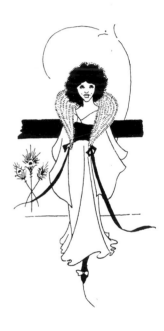

Credits

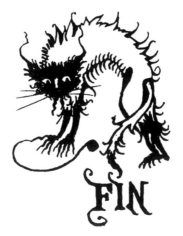

FIN

Front flap:
Illustration for Oscar Wilde's *Salome*, 1895

Inside flaps:
Prospectus for *The Yellow Book* (detail), 1895. Withdrawn because of the Oscar Wilde scandal

Back flap: : Illustration for *Lysistrata*, 1896